21.95

REFERENCE

ONLY

INTERNATIONAL ENCYCLOPEDIA OF ART

Mexican, Central and South American Art

first edition

John F. Scott

Facts On File, Inc.

INTERNATIONAL ENCYCLOPEDIA OF ART
MEXICAN, CENTRAL AND SOUTH AMERICAN ART

Cataloging-in-Publication Data available on request from
Facts On File, Inc.

Facts on File books are available at special discounts when purchased in bulk quantities
for businesses, associations, institutions or sales promotions. Please call our
Special Sales Department in New York at 212/967-8800 or 800/322-8755.

This is a Mirabel Book produced by:
Cynthia Parzych Publishing, Inc.
648 Broadway
New York, NY 10012

Edited by: Frances Helby
Designed by: Dorchester Typesetting Group Ltd.
Printed and bound in Spain by: International Graphic Service

Front cover: The stucco head of King Pacal the Great, was modeled sometime
during the period he ruled (615–683 A.D.) and found under his stone coffin.

10 9 8 7 6 5 4 3 2 1

Contents

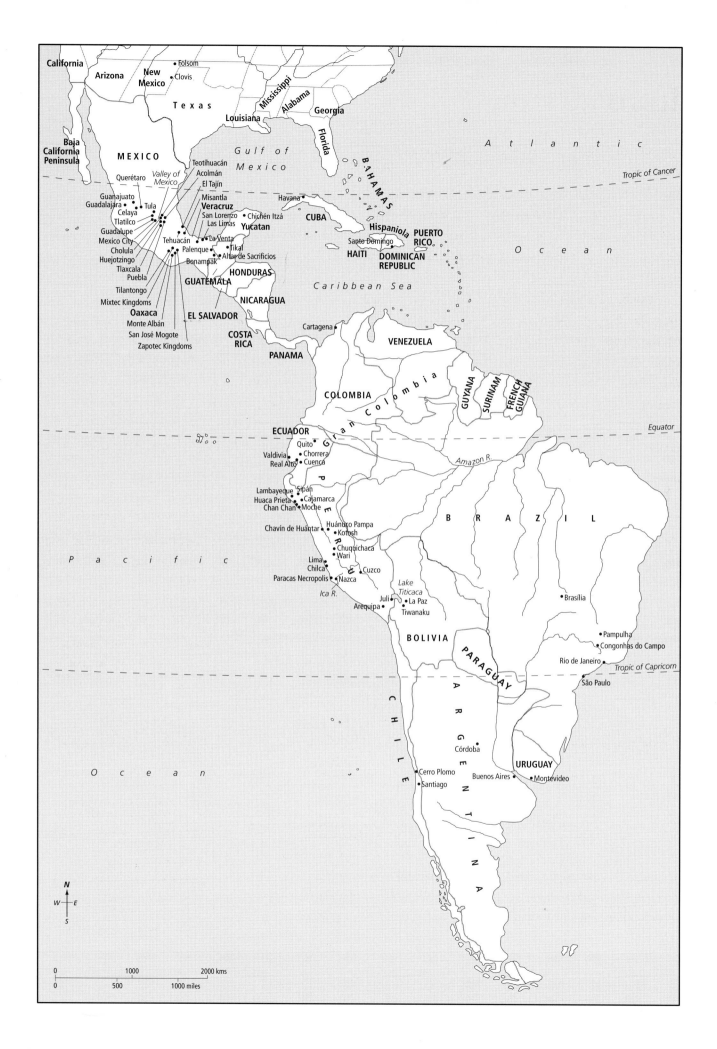

Introduction

The continents of North and South America, the Americas, are a vast landmass. They lie between the Atlantic and the Pacific Oceans and stretch from the north polar regions of Canada, through the United States and Mexico, past the Equator right down to Cape Horn, the southernmost point of land outside Antarctica.

Mexico, Central and South America cover a huge area, far bigger than Europe, reaching from north of the Tropic of Cancer to the far southern latitudes. The terrain varies from dry desert to thick rainforest, from snow-covered mountain peaks to swampy grassland.

The differences in climate and vegetation, especially in the great mountain range of the Andes, had a profound effect on the development of the people of this huge continent and their contact with each other.

Climate and geography provided the right conditions for the growth of societies that created great art in two main areas. The first area is what is now Mexico and western Central America and is usually called Mesoamerica (formerly Middle America), to distinguish it from northern Mexico and lower Central America. The second area is the central region of the Andes mountain range. In the rest of the continent, the harsh conditions of thick forest, wide rivers and swamps prevented the development of cultures that made permanent art.

For thousands of years societies and cultures of

Timeline

This timeline lists some of the important events, both historical (listed above the time bar) and art historical (below) that have been mentioned in this book. While every event cannot be mentioned it is hoped that this diagram will help the reader to understand at a glance how these events relate in time.

20,000–8000 B.C.: The first human beings wander into the Americas during the last Ice Age.

about 8000: The Ice Age ends and the sea level rises forming the Bering Strait. Agriculture develops in the Americas.

about 3000: People in northwestern South America begin to live in permanent villages.

20,000–1800 B.C.

20,000–8000 B.C.: Asian hunters bring their traditions of tool- and craftmaking to the Americas.

about 8000: Archaic period artists incise and paint animal images and include figures of human beings in these scenes.

about 3350–2000: Pottery is made in permanent settlements in northwest South America. Near Valdivia, Ecuador, pottery figurines are made.

about 3000–1800 B.C.: The peoples of coastal Peru decorate gourds and use them as containers. They also produce textile, baskets and stone items.

1800–100 B.C.: Formative period villages become larger and more permanent. People begin to live less by hunting and gathering and maintain gardens.

about 1200–6000 B.C.: The Olmec culture thrives.

about 900–200 B.C.: A religious center at Chavín de Huántar is built and people throughout Peru make pilgrimages to it.

1800–100 B.C.

1800–900 B.C.: Large, hollow ceramic figures are made in the central Andes and Mesoamerica during the Initial Ceramic period.

by 1200: Pottery figurines become larger and more sophisticated and pottery is in more common use in Mexico, Central and South America.

about 1200–600 B.C.: The Olmec culture creates huge public buildings, colossal stone carvings and develops a picture-writing system.

by 500: A Chavín style of art develops and spreads throughout Peru.

100 B.C.–600 A.D.: The Nazca culture flourishes.

1–700 A.D.: Moche culture flourishes.

750–1150: The Toltec empire flourishes.

1–800 A.D.: Cultures flourish in Mexico at Teotihuacán and in the Zapotec and Totonac kingdoms.

600–830: Late Classic Maya culture flourishes.

100 B.C.–850 A.D.

100–800 A.D.: Woven textiles become an important art form in south coast Peru.

100 B.C.–600 A.D.: Nazca artists make pottery and textiles and draw huge pictures in the desert.

1–700 A.D.: Moche artists make painted pottery.

400–1000: An imperial style of art is made in the central Andes at Tiwanaku.

450–650: Teotihuacán sculpture style develops.

600–830: Maya artists build pyramids, produce frescoes, plaster portraits and painted pottery.

750–1150: Toltec artists develop an imperial style.

the Americas began, rose and fell quite separately from other cultures in the world. Most of the world simply did not know that the Americas existed, or anything about the people that lived there. The values and beliefs of these isolated peoples were very different and this is reflected in their art.

In Mexico, Central and South America people generally worshipped a sun god and other gods too. People in each area believed in various stories about the creation of the world that told them how to please their gods and safeguard their world.

In the northern area, Mexico and Central America, there was a long tradition of human sacrifice, and thousands of people were killed to please the gods and ensure that the world remained safe. Some of these people captured enemies that they sacrificed to their gods. A ballgame connected with human sacrifice was invented.

Some of the civilizations of the Andes also were engaged in human sacrifice. Many of these cultures were authoritarian and dictated exactly what people should do. Very carefully organized forms of government came into being and the Incas, for example, did not allow any internal trade. In some of these civilizations everything was grown or made for the government. The government decided how and to whom it should be distributed.

The development of these cultures continued in splendid isolation long before the birth of Christ and until about 1500 A.D. Tracing the art history of these cultures is difficult, because all except the last of them, the Aztec and the Inca cultures, died out without any knowledge of their existence outside the Americas. The people in these lost cultures left few records for few of these peoples developed a written language. To find out about the place of art and its meaning in each society art historians can only look at the works of art themselves, how they changed with time and what they might tell us about the way of life of these people. Art historians

about 1200: The Chimor overrun the Lambayeque kingdom creating a large empire on the north Peruvian coast.

1200–1500: The large Maya states break into smaller ones.

1224–1461: Small Maya states come together again in the Yucatan peninsula under the League of Mayapán.

1375–1532: The Aztec empire flourishes.

1427–1532: The Inca empire flourishes.

1492: Christopher Columbus lands in the Bahamas and Cuba and founds the first new world settlement at Hispaniola.

1200–1499 A.D.

about 1200: Chimor artists decorate textiles with brightly colored bird feathers.

1200–1350: Mixtec artists create illustrated books recording the royal descent of each king. They also produce objects from precious metals and stones.

1375–1520: Aztec artists produce great temples and other buildings and decorate them with stone sculptures.

1427–1532: The Inca rulers impose artistic unity in their vast territory.

early 1500s: Roman Catholic friars are sent to the new world to convert the Indians to Christianity. The Portuguese begin to explore Brazil.

1502: Christopher Columbus claims the mainland of lower Central America and northern South America for Spain.

1521: Hernán Cortez brings down the Aztec empire.

1532: Francisco Pizarro brings down the Inca empire.

by mid-1500s: The Spanish set up the viceroyalties of New Spain and Peru.

1573: The Spanish Laws of the Indies are drawn up.

1499–1599

early 1500s: Aztec centers in the highlands continue to produce fine stone carving in the round in Mexico. After the conquest, Indians begin to make European images. The Spanish bring oil paints and European artistic styles to Latin America.

1540–1640: The Mannerist style of the late Renaissance is transferred to Latin America.

by 1550: The first great cathedrals are built by the Spanish in Latin America. Buildings in Mexico are built in the Plateresque style.

1580–1650: Cathedrals are built in Latin America in the Purist style.

by 1600: The Indian population is reduced to one-tenth of its orginal number due to ill treatment and European diseases.

1671: The Spanish Laws of the Indies are revised.

1630s: The Dutch form the colony of Bahia in Brazil.

1600–1699 A.D.

1600s: The Cuzco school of painting is established in Peru.

1640–1750: The Italian Baroque style appears in Mexico with the paintings of Sebastián López de Arteaga.

can also look at how ideas in art spread from one people to another, through similarities in objects found in different places and cultures.

In 1492 A.D. Christopher Columbus (1451-1506) sailed across the Atlantic Ocean and discovered the new world of the Americas. He thought he had reached the East Indies so he called the people he found Indians. Over the next forty years the Spanish conquered the areas of early civilization and imposed their own values, beliefs, art and government on the people. Soon the Portuguese followed and started to settle along the eastern coast of South America and much later the French, English and Dutch took over other small areas on the coast.

New diseases brought by the Europeans and harsh treatment of the native peoples by the Europeans took a terrible toll. Many Indian people died and their way of life was destroyed. The creation of art by the Indians was now put to the service of the Europeans. A new culture arose and a very different kind of art flourished.

From about 1521 A.D., the time of the European conquest, written records were kept in Mexico, Central and South America. The history of art becomes much easier to follow. By the nineteenth century there were important centers of art in many parts of the continent.

The chapters of this book are arranged so that developments that took place at the same time, but in different areas, follow each other. The cultural stages of development reached in the most advanced regions are hunter-gatherers, semi-permanent settlements, agricultural villages, early states, mature kingdoms and empires. The text first covers these stages in the cultures of the native Indian peoples. Cultural developments after the European conquest follow. The modern nations of Latin America became a minor part of the industrialized western world after their independence. This stage is discussed in chapters twenty-seven to thirty-four.

1807: King John VI of Portugal moves to Brazil.

1822: Dom Pedro of Portugal becomes the first emperor of independent Brazil.

1824: Independence from Spain and Portugal is achieved in mainland nations of Latin America.

by 1839: The four Spanish viceroyalties become fifteen republics.

1876–1911: Porfirio Diaz is dictator of Mexico.

1888: Slavery is abolished in Brazil and Emperor Pedro II is deposed by the army.

1889: Brazil becomes a republic.

1910–20: The Mexican Revolution takes place.

1917: A new constitution is written in Mexico.

by 1921: Mexico has a more stable government.

1960: Fidel Castro forms a Marxist government in Cuba. Brasília becomes the new capital of Brazil.

1970–73: Salvador Allende sets up a radical government in Chile.

1979–90: Daniel Orteaga comes to power in Nicaragua.

1983: Democracy returns to Argentina.

1985: Democracy returns to Brazil.

1717: The viceroyalty of New Granada is founded.

1776: The viceroyalty of La Plata is founded.

1700–1799 A.D.

1750: In Brazil many arhitectural projects are commissioned in the Rococo style.

mid-1700s: The Cuzco style of painting begins to have Rococo features.

1783: The Royal Academy of San Carlos in Mexico City is founded.

1783–1830 A.D.: The Neo-Classical style of architecture, sculpture and painting is popular.

1800–1899 A.D.

1814: King John VI brings a group of French academy artists to Brazil to act as faculty for the Imperial Academy of Fine Arts which is founded in Rio de Janeiro in 1816.

1830–1860: The Romantic style of art spreads to Latin America.

1847: Art teachers from Spain and Italy are brought to Mexico to reopen the Academy.

1850–1900: Academic Realism is popular in Mexico.

1890–1920: The *Modermismo* movement develops in Latin America.

1900 A.D.–present

about 1921: The Mexican government invites Mexican artists to paint murals in public buildings.

1922 to about 1970: Latin American artists experiment with abstract European styles of art.

1938–1970s: Surrealism becomes an important art movement in Latin America.

1956: Lúcio Costa wins the design competition for Brasília.

1970s–1990s: Latin American artists work in many international styles including the Imformalist style. Artists find a market for their work in Latin America and internationally.

1 The First Ice Age Americans

The New World

Human life existed for nearly two million years before any people settled in the Americas. During the last Ice Age the polar ice caps grew in size and the sea level dropped. Bands of Ice Age hunters followed large animal herds across a land bridge between what is now Siberia and Alaska. When the Ice Age ended in about 8000 B.C. the sea level rose again. The Bering Strait formed, separating Siberia from Alaska, and isolating the hunters in the Americas. They had brought their crafts, and also their Ice Age ideas. Because these people became isolated their languages developed differently into a distinct group of languages called Amerind. ■

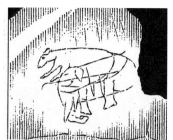

◀ *A mastodon bone from the Valsequillo Dam in Mexico, dated about 20,000 B.C., was incised with images of two Ice Age animals Indians hunted. One, a deer, is incised over a mastodon. By copying them the artist tried to capture the animals' spirits.*

The American Indians Christopher Columbus found when he arrived in 1492 A.D. were descended from Asian hunters who wandered into the Americas over thousands of years, during the last Ice Age, between about 20,000 and 8000 B.C. Men hunted large Ice Age mammals for food, clothing and tools. Women helped cut up the animals' bodies and prepared the hides and meat. They also collected plants for food, and materials to make crafts. Craftmaking involved creating something useful from natural materials. When the appearance of objects becomes more important then art develops.

The Indians made tools of stone, bone and horn. They chipped stones and attached them to wooden shafts to make spears for hunting. The finest Ice Age spear heads were made by chipping off the edge of a stone by pressing on it with another tool. The first spear head discovered had a very wide point and a dimple at its base. It dates from between 9500 and 9000 B.C., and was found in Clovis, New Mexico. Similar objects have been found in the eastern United States and South America. Smaller, fish-tail points, first discovered in Folsom, New Mexico, were also found throughout South America. Hunting was very important, so fine spear points must have been a mark of a great hunter. Ice Age artists in the Americas did not make many images of animals and no rock paintings have been found.

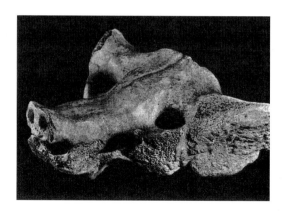

▲ *A hunter from central Mexico used the hip bone of a camel to make this carving because the artist saw an animal face in its shape. A carver changed a few parts such as the nose to make it look like a dog or wolf between 10,000 and 8000 B.C. It is about six inches/fifteen centimeters long and was found near Tequizquiac in central Mexico.*

Extinct Animals

Ice Age mammals in the Americas included many kinds of elephant-like mammals, saber-toothed tigers, giant sloths, and scaled glyptodonts (like armadillos). The great Ice Age mammals became extinct around the world between 10,000 and 8000 B.C. They became extinct because of weather changes or overhunting. ■

2 Semi-Permanent Settlements, approx. 8000–2000 B.C.

Early Settlements

When people had to give up hunting large animals, and spend more time gathering plants for food and hunting smaller animals, they stopped moving around. They settled near sources of reliable plant food or by waterholes and streams where they could catch fish or birds. They did not make permanent settlements, but stayed in each place as long as food supplies lasted. ∎

After most large animals died out about 8000 B.C., rabbits, guinea pigs, fish, birds and insects became important for food. People hunted these small animals and spent much more time collecting plants for food. They began to grind seeds and other coarse materials on a smooth stone mortar with a handstone. This is called the Archaic period, the time before people developed agriculture.

Archaic art focused on animals. Just as the people of the Ice Age had incised their animal images, archaic artists painted and incised rocks probably to capture the spirit of the animal they were going to hunt.

Rock paintings from this time have been found in the Andes, but not in Central America or Mexico. The images were made on rock under shallow overhangs. They could be seen in natural light, not like the deep-cave paintings in Europe. Unlike the Ice Age artists, Archaic people put human beings in their scenes. These works of art make us recognize the power of men when they act in a group to outsmart the faster animals.

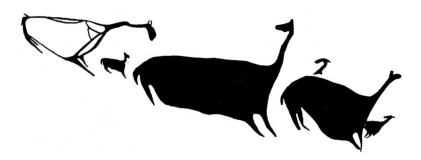

▲ *In the far southern flanks of the Andes in Peru, rock paintings show scenes with small, figures usually painted in one color, either red or black. Paintings from the central Peruvian highlands depict the wild camel-like ancestors of llamas and alpacas; they are occasionally pursued by hunters. The animals range from about four inches/ten centimeters long to over three feet/one hundred centimeters long. This rock painting of large animals from the Andes at Chuquichaca, Peru, dates from the Archaic period, about 6000 B.C. This is a large, black painting with fluid lines and a sense of movement. The animals' heads are turned, looking over their shoulders. The overlapping of the animals, creating a sense of depth, is unusual.*

Hunting and Gathering—a Continuing Lifestyle

The Archaic lifestyle survived until recently in parts of the Americas that are unsuited to agriculture. There were fishing people in both the extreme north, and the extreme south, who braved the cold in animal skins. Indians in the Great Plains of North America, the llanos of Venezuela and Colombia and the pampas of Argentina developed surprisingly similar lifestyles. This was especially so after the introduction of the horse by the Spanish after 1500 A.D. which allowed them to move about more quickly. Desert conditions like those in the Great Basin of the American west, northern Mexico and northern Chile did not allow crops to grow. People, therefore, hunted birds, fish and animals with nets. In the pampas a *bola*—two stones connected with a long line of rope—was used to trip up the feet of rheas, a type of bird that ran quickly but could not fly. ∎

3 The Earliest Pottery, approx. 3350–2000 B.C.

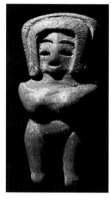

◀ *Valdivia potters modeled the earliest known human figurines from pebbles smoothed by water. They carved vertical lines to represent hair on the heads of these figures. After about 2300 B.C., pottery figurines like this female figure with a full head of hair were made with tall, rectangular proportions.*

Ancient Pottery

Pottery is a favorite material of archeologists because it is so durable. It can be broken into pieces, but the pieces, called shards, can resist the forces of nature and survive for thousands of years. One way to trace the development of a people's art is to look at its pottery shards. To make pottery, clay is fired or heated slowly to a high temperature to keep it from turning into mud when it gets wet. Ancient pottery was made from earthenware clay, still quite soft and porous when fired. The clay was pinched or coiled into shape. When it was nearly dry it was rubbed to make it smooth and less porous. Pots were probably put in a pit with hot stones to fire them. ■

Toward the end of the Archaic period, about 3000 B.C., people in northwestern South America began to live in permanent villages. They stayed in one place because fish and shellfish gave them a steady supply of food. They also learned to cultivate plants such as manioc, a starchy root vegetable, and corn. The conditions were right for them to begin to make pottery. Pottery breaks easily unless it is moved carefully, so it is only used by people in permanent settlements.

The earliest pottery, found near the present port city of Cartagena, on the Caribbean coast of Colombia, was made about 3350 B.C. Those artists found clay could be easily shaped with just light finger pressure to create patterns or grooves which sometimes suggested faces. Later cultures continued to model similar animal heads on the sides and rims of bowls, especially in the area east of Colombia, now Venezuela and the Caribbean islands.

Farther south, in what is now Ecuador, the people living near Valdivia made little human figurines, first in stone and then in clay. They built the largest town of that period, known as Real Alto, which had about 2000 inhabitants. Oval houses with mud-covered log walls and thatched roofs housed about thirty people each. Tropical rainforest Indians make buildings like this today. There were similar houses made of reeds at Chilca, on the south-central coast of Peru, dating after 3500 B.C. and people built partly sunken oval houses in the Tehuacán Valley of Mexico around 3000 B.C.

People of the Tropical Forest

The Amazon contains the last groups of Indians not affected by western civilization. They are quickly vanishing, however. Small gardens near Indian villages in the Amazon today provide extra food supplies, even though hunting of animals and collecting fruits and roots give the Indians a reliable source of food. These Indians make pottery, finely decorated with incised and painted lines. They live in large, wood and thatch buildings often oval in shape. Hammocks, invented in South America, provide a place to sleep or relax. ■

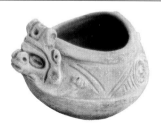

◀ *This pottery bowl from southeastern Santo Domingo, was made by the Taino people of the Integration Period, about 1300 B.C. Its details are like those found on the earliest shards from Colombia.*

4 Textiles in Pre-Ceramic Peru, approx. 3000–1800 B.C.

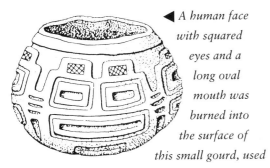

◀ *A human face with squared eyes and a long oval mouth was burned into the surface of this small gourd, used as a container, from Huaca Prieta on the north coast of Peru. It dates from about 1900 B.C.*

Making Cloth Without a Loom

The textiles made in Pre-Ceramic Peru were very small, only four to six inches/ten to fifteen centimeters long by three to four inches/eight to ten centimeters high. They were made by twining thread together by hand. Some of the pieces clearly show designs in black and red contrasting with brownish-yellow. These small pieces of cloth probably used to make bags. ■

▲ *Imaginary animals such as this condor with a coiled serpent inside its belly, were woven into Peruvian cloth around 2000 B.C.*

The time before pottery or ceramics were made in the wide coastal area of what is now Peru, is called the Cotton Pre-Ceramic period. It is given this name because cotton was the main agricultural product of the area, although other plants were also cultivated. Gourds, for example, were grown for use as containers and other plants were grown as food.

The coastal people also took food from the sea. They traded with people in the highlands for root crops, like potatoes, and domesticated animals, such as llamas and guinea pigs. The highland and coastal people also shared art forms.

It is surprising that these people did not make pottery because the coastal Peruvians knew about Valdivian ceramic art. The decoration on their gourd containers is like the decoration on Valdivian pots. Perhaps there was no need for pottery because their cultivated gourds were just as good as pottery containers, and were easier to carry on the seasonal trips they made to the highlands.

Textiles, baskets and stone items were also produced. Textiles, woven from cultivated cotton, were the most accomplished and interesting art form in this period in Peru. They remained the most important art in this area until the Spanish conquest soon after 1500 A.D. Their designs look like those of Chimor textiles from the north coast of Peru, which were made 3,000 years later. The small pieces of cloth made in the Pre-Ceramic period do not seem to have been used as clothing.

The Cotton Pre-Ceramic people also built temples that were advanced in design. In central Peru, huge courtyards were built up the sides of natural hills on manmade terraces, leading to small rooms perched at the top of the hill.

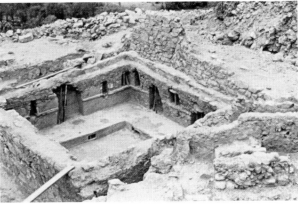

◀ *This temple at Kotosh in the highlands of Peru, built about 2000 B.C., has a pair of crossed stucco hands modeled into the wall.*

5 Villages of the Formative Period: 1800–100 B.C.

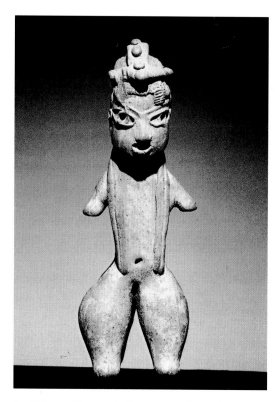

▲ *This small ceramic figurine made in the Tlatilco style of central Mexico is decorated with little balls and bands of clay applied to the surface. The clay is punched and grooved to create details. It dates from 1000 to 500 B.C.*

Between about 1800 and 100 B.C., known as the Formative period, villages became larger and more permanent. Fewer people went hunting and gathering. More stayed to tend gardens. The houses were built in rectangular shapes, so they could be packed closer together. Special public buildings were also built. Pottery came into common use and figurines became far more popular.

Mexican figurines were modeled in a wide range of styles. They were made as a solid piece of clay. They had to be small because large, solid pieces of clay explode in a hot kiln. They were designed with different costumes, posed in many positions and are graceful and lively. Most are female figures but male figures have also been found. Groups of figurines have been found buried together.

By 1200 B.C., pottery figurines in Mexico, Central and South America became larger and more sophisticated. They were now made with a hollow interior so they could be fired without exploding, and were painted white, black, red, yellow and tan. Large, standing figures in the style called Chorrera, after the village where they were found, were masterpieces from coastal Ecuador. Figures like monkeys and snakes, all in their natural postures, yet simplified in more geometric shapes, were also modeled to decorate ceramic pots.

Large, hollow ceramic figures were made in both the central Andes region and in Mesoamerica during the Initial Ceramic period from 1800 to 900 B.C. The earliest ceramics made in Mesoamerica were already very skillfully made. They were shaped like the gourds which had been used as containers by the Cotton Pre-ceramic people of Peru.

Chorrera Ceramics

Large standing figures have been found on the Ecuadorean coast. It has been suggested that the idea of hollow figures, also made in the central Andes, Mexico and Central America, originated in Chorrera because of its central location between the two areas. Its people may have made long-distance trading voyages on large balsa sailing rafts. They traded orange-colored shells which they considered valuable and probably carried their ceramic art with them. With clear, bold forms; easily recognizable, bright colors; and incised outlines this strong style was likely to have been admired and copied. ∎

This Chorrera figure ▶ with closed eyes, smooth helmet, and swelling body parts was made between 1000 and 300 B.C. Its color is painted between incised areas in a clay wash which was left dull or sometimes polished.

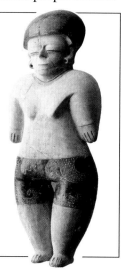

6 Olmec Art, approx. 1200–600 B.C.

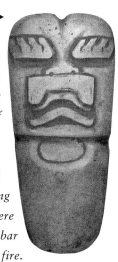

A jade axhead ▶ excavated at La Venta, Tabasco, on the southern Mexican Gulf coast, is carved with the snarling mouth and snub nose of a jaguar. A notch represents the soft spot on a baby's head and can look like sprouting corn. Facial features were rubbed with cinnabar to look like fire.

Basalt and Jade

Basalt, very hard, dark stone was important to the Olmec. They used it to make colossal portrait heads and the thrones of their rulers. It was transported by raft along the coast and on the slow-moving rivers, from the nearest quarry in the mountains at least fifty miles/eighty kilometers away. Basalt is solidified lava which comes from volcanoes. To the Olmec it symbolized the earth's fiery power. Natural columns of basalt were broken off from the mountains, dropped into the Gulf of Mexico and transported to La Venta. They were used to fence in sacred spaces and to make tomb chambers.

For the Olmec, jade, which is heavy and cool to the touch probably symbolized water. With its blue-green color, it looks like water is locked inside the stone. In the early 1500s, Mesoamerican Indians considered jade more valuable than gold. ∎

The earliest of the high cultures in Mesoamerica is known as the Olmec. The culture first appeared around 1200 B.C. at San Lorenzo in Veracruz, Mexico. Huge public buildings and colossal stone carvings were made. Only a powerful ruler could demand so much work of his people. The town of San Lorenzo was located on partially man-made tableland. Its plan may once have looked like a bird or a cat's paw with wings, a design which was also scraped into the surface of many Olmec pots. The top of the site was drained by basalt channels that emptied into basins carved to look like giant ducks or toothless baby jaguars.

Jaguars, eagles and serpents are the images of Olmec gods. These animals represented the forces of nature such as the rain god and fire god, and were incised and/or carved on axheads of precious jade or other green stone. Finding the scarce green stone was a major reason for long Olmec trading trips. These trips allowed the Olmec to spread their customs and religion far and wide. At La Venta, the Olmec capital from 900 to 600 B.C., vast deposits of green stone were buried for safekeeping and sealed underground with abstract stone mosaic masks of the jaguar god to fend off robbers.

In their art, the rulers of the Olmec are shown with their gods. Large basalt throne bases at San Lorenzo and La Venta show powerful men holding rambunctious jaguar children. The seventeen known colossal basalt heads are probably portraits of Olmec rulers. Each head can be recognized by its own helmet headdress. Each face is different in shape and expression, but all have very alert, wide-open eyes, with a ruler's air of command.

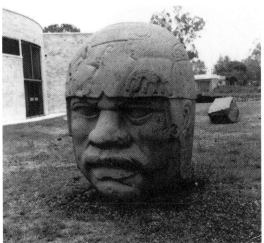

◀ *This colossal stone head from San Lorenzo, has a carved, jaguar pelt paw draped over it. It weighs over five tons and was probably floated down the Gulf of Mexico on a raft from the mountains sometime before 1000 B.C.*

7 Chavín Cult Art from Peru, approx. 900–200 B.C.

Peru's Regions

The modern country of Peru is divided into three dramatically different regions. Near the Pacific Ocean is a desert coast. East of the coast rise the high Andes Mountains with their snow-covered peaks and volcanoes. The mountains descend into the tropical forest at the start of the Amazon River, which flows east 2000 miles/3200 kilometers to the Atlantic Ocean in Brazil. ■

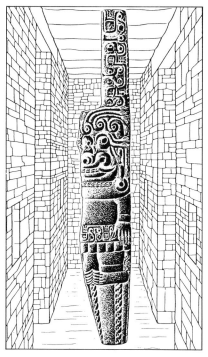

▲ *At the intersection of two central passageways in the temple at Chavín de Huántar stands the figure of a fanged monster carved in low relief on a huge, dagger-shaped stone. It is called the Great Image and was made between 800–500 B.C.*

High in the central Andes Mountains of Peru, a religious center at Chavín de Huántar was built between 900 and 200 B.C. It is thought that people throughout Peru made pilgrimages there, to consult an oracle of the Great Image. No one knows who the pilgrims to Chavín were or the language they spoke.

A wide range of sculpture and architecture has been found at Chavín, probably because artists and architects from all over Peru came to serve the oracle and brought together the styles first developed in different regions of the north-central coast and the northern highlands of Peru.

By 500 B.C., the Chavín style had developed and spread throughout Peru, from the far north to the south coast. The spread of the Chavín art style shows that, for the first time in Peru, previously separate local cultures were brought together.

The architecture of Chavín de Huántar developed from earlier coastal constructions. The main temple plan was U-shaped. A large building was flanked by two wings that reach out to enclose a plaza with a circular, sunken court in the center. This arrangement symbolizes the earth, with the sunken navel-like court suggesting the entrance to the underworld and terraced levels rising up to make an artificial

Mother Cultures

By about 500 B.C. two powerful cultures, the Chavín in Peru and the Olmec in Mexico and Central America, had expanded from their homelands and unified many parts of their surrounding regions. Each developed a culture that produced great architecture and fine stone carving. Their art styles, religious beliefs and political organizations spread widely and dominated throughout the region. The Chavín and Olmec cultures are called "mother cultures" because they influenced the development of other cultures.

Trade brought the different peoples of each area together. Soldiers were probably sent to protect the traders. Objects made of valuable materials were widely traded. The most important thing these people had in common was religion. In daily life, people kept their local differences but a common religion was practiced over a wide area. Objects produced by artists and craftsmen were made in similar styles and drew on the same religious images. ■

▲ *Bowls and bottles are the earliest forms of pottery found in the passageways of the stone temple at Chavín de Huántar. This fine example of polished black pottery is decorated with animal forms. Its open spaces are filled with lines made by rocking the edges of scallop shells on the partially dry clay. It dates from between 500 and 300 B.C.*

mountain. This landscape was familiar to the people of the Andes. Underground passageways tunneled into the core of the main structure. They may have looked like caves penetrating the heart of a mountain.

Heads of human and animal creatures were carved on the projecting ends of stones in the walls of the temple. They seem to stare down at the visitor. Their heads emerge from the forty-foot/twelve-meter high wall of smoothly cut stone. They are bulbous figures, bursting with life. The Chavín art style stresses how the spirit world provides abundant life forms.

Human representations at Chavín are more rare than animal images. The Great Image, the object of pilgrimages to Chavín, was originally carved in the form of an imaginary animal. Later Chavín images were much more human in appearance because a lower jaw and human teeth were added to animal heads. These later images are known as smiling gods, and have feline mouths (as do important Olmec human figures), serpent hair and clawed feet. Other images have been found with turned-down mouths sporting four-headed snake belts and holding vertical staffs in both hands, stretched out to the sides. These are called staff gods. A staff god made of hammered gold was found at the northern site of Chongoyape. Staff god images, painted in shades of brown on cotton textiles, have been found in the Ica Valley of the south coast of Peru. Textiles, works in gold, and other small objects depicting the images of Chavín gods and other figures were spread throughout the region.

Pottery found at Chavín de Huántar draws on themes from the large stone carvings. The best pottery was probably left in the passageways of the temple as offerings. This highly polished black ceramic was incised and carved with animal motifs such as reptile scales, bird wings, and cat claws.

Chavín and Olmec Religion

Archeologists think the Chavín must have had a smiling god; a snarling god; and a staff god. The staff god carries staffs in his hands, and may have been a creator god. The Olmec and Chavín religions used images of large animals such as the jaguar, eagle and cayman as symbols, suggesting contact between the two cultures, or that their religions developed from a common belief system. ■

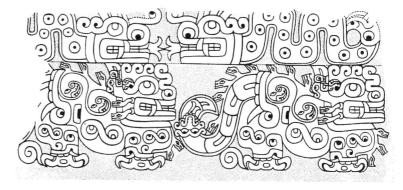

▲ *This detail of a cornice stone, cut with sharp precision from the temple of Chavín de Huántar, about 400 B.C., reveals the figure of a jaguar. Some of its spots look like animals and eyes. Others look like serpents coiled into figure eights. The entire body of the jaguar becomes the head of another giant jaguar that spits the tail out of its jawless mouth.*

8 | Clothes for the Dead

The Classic Period

In Mexican, Central and South American art, the Classic period, 100 B.C. to 800 A.D., is the time when several civilizations flowered. The civilizations created states in Mexico, western Central America and the Central Andes based on the early cultures of the Olmec and Chavín. Some conquered large territories belonging to cultures similar to their own. Large numbers of people lived in cities. ■

▲ Members of the cat family were important in all Indian cultures of the Americas. The Chavín represented the jaguar in their arts. The tan coats of cat images at Tiwanaku in the southern Andean highlands are probably mountain lions, called pumas. Mesoamerican Aztecs of the fourteenth to the sixteenth centuries called any spotted cat ocelotl, the ocelot in English, and often pictured them in their art. In this illustration, a cat god with white whiskers around the mouth and a diving, white bird attached to its forehead was painted on plain, woven, cotton cloth. Because of its style, it is probably a necropolis textile from the period when the Nazca was developing from the Paracas culture about 100–1 B.C.

Woven textiles became the most important art form in south coast Peru at the beginning of the Classic period (about 100 B.C.–800 A.D.). The leaders of the people at Paracas and others of high status were mummified after they died and buried in square stone tombs sunk in the desert sands. These tombs and their contents, like those of the pharaohs of Egypt, have been preserved by the extreme dryness of the Peruvian desert.

The mummies were buried with up to 200 pieces of cloth, some plain but many elaborately decorated with bright red, blue, black, yellow, pink, green and white wool. These pieces were often stitched onto large cotton mantles or cloaks. They are called necropolis textiles because they were made for burials. A necropolis is a cemetery. Patterns were embroidered, painted and woven into the textiles.

Textiles were mainly woven on a backstrap loom. In these looms the warp threads are held at one end on a fixed piece of wood and, at the other, on a piece of wood with a strap worn by the weaver. When the weaver leaned back the warp could be kept taut so that the weft could be threaded through the warp to form the cloth.

Women embroidered figures on mantles using bone needles. The needleworkers did not plan the designs in advance, so textiles from Paracas show many different and imaginary designs. The design elements are repeated in these embroidered textiles. Changes in color and the direction of figures bring variety to the designs. Human forms float on the surface of the cloth, carrying severed human heads in their hands. The Indians believed heads contained the souls of their enemies.

▲ These "bird men" were embroidered on a mantle found unfinished in a burial site. Since it was used before it was finished, the man it was being made for probably died before it had been completed.

Classic Art from Nazca, approx. 100 B.C.–600 A.D.

Desert Pictures

The Nazca drew huge pictures in the desert by digging a continuous shallow furrow into the ground. These were not discovered until photographs were taken of them from airplanes. Straight lines running for miles and images of birds, monkeys, fish, spiders and flowers can be seen from the air. The lines were probably made for ritual pilgrimages and laid out in the rocky ground using long cords. ■

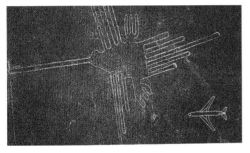

▲ *This large drawing in the earth of a hummingbird could have been seen from the ground or from nearby hills. The drawing of a jumbo jet on the right gives an idea of scale.*

The Nazca culture of the southern coast of Peru is very mysterious. We do not know what kind of government the people had or who their rulers were, but we believe their art developed from Paracas art. The Nazca did not build cities, but many adobe buildings have been found at Cahuachi, the center of Nazca culture, including pyramids still visible in the desert. The site probably was used only for feasting, worship and burials. Much of Nazca art, found in perfect condition in burials sites, showed nature's richness. Plump fruits and animals were painted in bright colors on pottery. The same subjects, in a simplified form, were woven on textiles or dug into the desert floor. Nazca textiles were typically made on a loom, with woven designs. The designs were more geometric than the free-style embroidery of Paracas necropolis mantles. For the first time in Peru, pots were painted before they were fired, with as many as six colors. This technique made the colors much brighter and longer lasting. By 1 A.D., pottery took the place of textiles as Nazca's most important art.

The cat god continued to be an important image in Nazca art and it was now painted by artists on pottery instead of just appearing in textile designs. The cat god became more simplified in Nazca pottery. Whiskered mouth masks, probably representing cats, and forehead ornaments representing diving birds have been found in Nazca burial sites. They are made from hammered sheets of gold. It is believed that Nazca rulers might have worn these gold ornaments. Dressing like the cat god perhaps showed that the ruler shared some of the powers of the god.

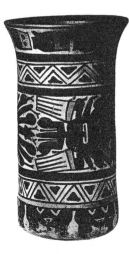

◄ *Representations of spirits became common in late Nazca art of 400 to 600 A.D. The spirit faces at the bottom of this vessel support the figure of a spiky god above.*

Beautiful, ▶ thin-billed birds decorate this low, pottery bowl made by the Nazca culture of the south coast of Peru, between about 100 and 300 A.D. Six different colors—red, two shades of brown, orange, black and white—were painted on the white clay background color of the bowl.

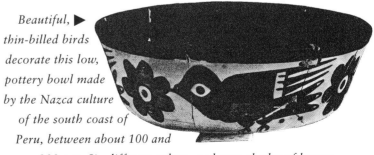

Moche Art, approx. 1–700 A.D.

▲ *The Pyramid of the Sun in Moche, Peru, built between 200 and 500 A.D., has a long terrace of adobe bricks with steps leading up to a platform 135 feet/40.5 meters high. It was probably the residence of the ruler and his court and enlarged every time a king died.*

The Moche Empire

Between 200 and 600 A.D., the Mochica culture conquered many of the people living in the river valleys along the north coast of Peru. At its height, the Moche empire stretched from north of present-day Lima to just south of the modern Ecuadorian border. Some of the peoples kept their cultures and maintained a different style of art. Moche rulers imported their own style for rituals and burials. ■

◀ *This jar, from about 500 A.D. is painted with a scene of prisoners being led to a Moche leader seated on a pyramid.*

By about 200 A.D. when the Nazca culture flourished on the south coast of Peru, on the north coast, the Mochica-speaking people also flourished. The Moche people made many images of themselves, their activities and beliefs. One ruler, the "warrior priest", whose grave has recently been found at Sipán, was buried with a gold mask over the lower part of his face.

Moche artists painted with thin brushes on the rounded bodies of jars and produced a wide range of real and imaginary scenes. Figures hunting, running and fighting are set in a dry, cactus-filled, desert landscape that still surrounds the fertile river valleys of this area. The rocky desert surface is represented by wavy lines and flecked marks. More elaborate scenes are placed in bands around the jars separated by heavy, black lines.

Early rulers usually played the parts of gods, a sign of their right to rule. In the Moche culture, there was a creator god, who sat in a mountain cave accepting human sacrifices. His son, an active god, helped people farm and fish.

Terraced pyramids, like those painted on ceramic bottles, actually loomed over the cities of the Moche kingdom. Two major structures symbolize the presence of royalty and the gods in the capital city Moche. The larger, called the Pyramid of the Sun, was used as the palace. The smaller, now called the Pyramid of the Moon, has murals that look like the paintings the Moche people made on ceramic bottles. Because few human remains have been found in the smaller pyramid, it was probably used mainly for religious purposes. The two pyramids of the city face each other across a broad plain that was once filled with houses but is now covered with drifting sand.

Molds for Pottery

In Peru, Ecuador and Mesoamerica, molds were used during the Classic period to make pottery sculptures to guaranteed quality and an accurate likeness. Toward the end of the Classic period, molds for the backs of images were no longer used. ■

Late Moche jars bearing realistic portraits of ▶ rulers with the same face were made from molds.

11 Classic Art in Mexico, approx. 1–800 A.D.

Teotihuacán Origins

Experts cannot agree on what language the Teotihuacán people spoke. Their name comes from the name for the site of the city in the Nahuatl language which means "the place where the gods were born". Under the Pyramid of the Sun at Teotihuacán is a cave. The Teotihucán people probably believed it was their place of origin. ■

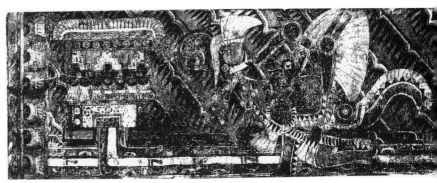

▲ *This scene was painted on a fresh plaster wall in the Atetelco palace at Teotihuacán, built about 500 A.D. It shows the front of a temple, with feathers on its roof, placed on top of a low platform with a central staircase. The footprints on the stair and path show the steps taken by the large cat on the right whose body seems to be made up of net.*

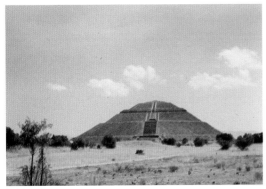

▲ *The Aztecs named this building the Pyramid of the Sun over a thousand years after it was built in about 100 A.D. at Teotihuacán in central Mexico. Underneath the main staircase is a cave ending in a lobed chamber directly under the center of the pyramid. The Aztecs believed their first people came from a lobed cave like this. This cave was probably a sacred place for the Aztecs for it was an entryway to the heavens and the opening to the underworld. Caves also were sacred to the rain god. Bodies of children found at the four corners of the Pyramid of the Sun may have been sacrificed to please the rain god. The Aztecs believed the sky would weep in sympathy.*

While Nazca and Moche art was being made in Peru, between 1 and 700 A.D., far away in Mexico, a number of different cultures were flourishing and influencing each other in this Classic period. The greatest of them was centered on Teotihuacán, in the northern part of the valley of Mexico, which grew to a population of 200,000. Others were the Zapotec kingdom in the Oaxacan region, with its capital at Monte Albán, and the Totonac kingdom, the capital of which was at El Tajín in eastern Mexico.

A man-made mountain looking like a volcano had dominated the Olmec capital of La Venta between about 1200 and 600 B.C. At Teotihuacán in the northern part of the valley of Mexico, around the year 1 A.D., this idea was taken to its logical conclusion. There, the largest pyramid of the Classic period 738 feet/225 meters square and at least 184 feet/56 meters high, was built, of earth braced with angled stone walls. The pyramid was erected in one construction program and not in stages. Its square plan reflected the division of the universe into east, west, north and south directions. The sun sets directly opposite the staircase, located on the west side, on the longest day of the year.

On the tops of early pyramids wooden temples were built and decorated according to the religious season. Two fresco paintings at Teotihuacán show that the temples were low buildings with one wide door. The roofs had circular clay reliefs decorated with feathers.

City of the Gods

Long after the people who built it disappeared and after the Europeans arrived, Teotihuacán remained an important religious center. They told the Spanish that Teotihuacán had been built by a race of giants, probably because the Aztecs had uncovered extinct mammoth bones nearby. They believed Teotihuacán was the place where the gods had gathered the last time the sun had burned out and the world had to be recreated. Aztec myth said that the gods sacrificed themselves to nourish the sun with their blood. This put mankind forever in the gods' debt. ■

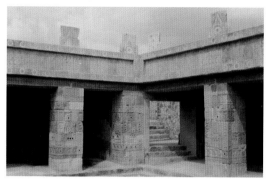

The palace of ▶ Quetzalpapalotl would have been a good place for receptions for priests or nobles. Its patio is totally enclosed and has columns carved in stone showing low- relief creatures that are part bird and part butterfly with shiny black obsidian eyes. The rectangular columns and heavy cornice create a design of right angles typical of Teotihuacán style between 250 and 650 A.D.

In the huge, planned and organized city of Teotihuacán, buildings lined the great north-south avenue linking the plaza of the moon pyramid with the great market and the main religious enclosure. Behind the central avenue, many other residential enclosures follow a grid measuring 187 feet/57 meters square. The entrances to the enclosures were made so they were difficult to find to discourage outsiders from coming in. Inside were many private homes. There were open patios in the middle of most of the homes and shallow porches opening onto the patios from all four sides. Mythical scenes and religious rituals were painted inside the porches.

Large public works would have required a large labor force, so this city must have had a ruler who would require the 200,000 residents to obey him. The ruler's palace was recently identified inside the citadel next to the Temple of the Feathered Serpent. Because of its small size, the administrative work of government must have been done somewhere else. No portraits of the kings who ruled this state have been found, although eight people of high status were recently identified by hieroglyphs, or picture-writing symbols.

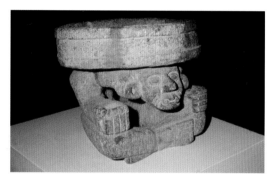

▲ *Teotihuacán sculptures were made in a distinctive style. This fire god's shriveled body is simplified into a cube shape that supports a bowl for burning offerings. The trapezoidal face shape is found wherever Teotihuacán exerted control between 450 and 650 A.D.*

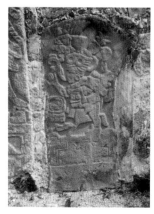

◀ *This stone of about 400 A.D. in Monte Albán gives information about a Zapotec ruler named Eight-Deer. The hieroglyphs give his birth date and the name of a hill, probably his home town.*

Ancient Mexican Writing

Hieroglyphs or picture-writing in Mexico began as early as the Olmec period, between 1200 and 600 B.C. Generally, it is difficult to read. Writing of the Classic period, between 1 and 800 A.D. however, is easier to read. Numbers are represented by a dot for number one and often a bar for number five. The symbols for days are pictures of animals or plants. Place names were written with a picture of a hill or a mat or rug representing the home. People's names were very simply drawn. For example, one name is represented by a bird's claw and a face. ■

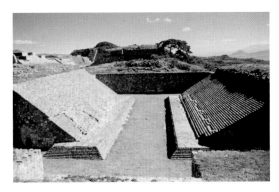

▲ *A ballgame played with a rubber ball was a standard activity in every Classic Mesoamerican city. This rectangular ballcourt found at Monte Albán, Mexico has vertical and sloping surfaces against which players hit the ball. The opposing team returned the ball. Neither team could use their hands. If the ball fell at the court's open ends, it was put out of play and the team which hit it received a fault. Spectator space was limited to the building tops next to the court. The stepped area, which looks like bleachers, was originally plastered in about 600 A.D. to create two smooth sloping walls.*

Teotihuacán was the largest city of its day in the Americas and had considerable impact on Mesoamerica between 450 and 650 A.D. The state took in many people from areas throughout Mesoamerica and people who spoke different languages: Zapotec, Totonac and Maya people. People from other areas admired the city and its art.

There were many skilled craftspeople in Teotihuacán who made very high quality artifacts. Pottery tripods and fine orange pottery vessels were traded widely, as was shiny obsidian, a black or green volcanic glass used to make tools such as knives and mirrors. The Teotihuacán people acquired goods such as cacao and bright feathers, from the tropical lowlands. Teotihuacán spread its influence to western Mexico, east to Veracruz and south to Oaxaca and the Maya.

Before Teotihuacán grew to be the dominant city in Mesoamerica at the beginning of the Classic era, the Zapotec kingdom in Oaxaca had been an independent state. The architecture at the capital of Monte Albán looks something like that at Teotihuacán, but was more exactly aligned around the central plaza. Major groups of buildings were planned as strict rectangles, each with a central patio, a pyramid at one side and a low platform at the other.

El Tajín, in eastern Mexico, was the capital of the Totonac state. The ritual Mesoamerican ballgame probably began in this eastern area. By 1000 A.D., El Tajín had at least eleven ballcourts. At the south ballcourt, a series of reliefs shows events connected with the game. Men played the ballgame to bring back the sun from the underworld through their blood sacrifice, just as the gods themselves had done to revive the world in its most recent creation. After the ballgame, the sacrificial player's blood was shed. One panel of the relief shows the sacrificial victim's heart being cut out and offered to a sky god.

At El Tajín, a relief of about 800 A.D. shows two opponents facing each other in the ballcourt. They wear thick U-shaped belts as protection from the hard, rubber ball. ▼

The design of the central pyramid in El Tajín, built after 600 A.D. has 364 square recesses in its four sides. The pyramid may have been built to represent the solar year. ▼

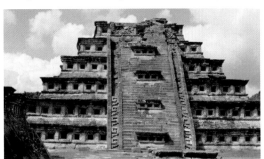

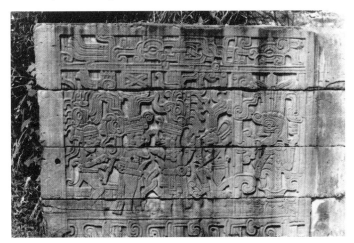

12 Maya Art Around Guatemala, approx. 250–830 A.D.

Maya States

The Maya land was divided during the Classic period into city-states, each with its own ruler. Recent translations of hieroglyphs show that the names of the kings of the city-states are often linked with the names of one of two large cities: Tikal or Calakmul. These alliances suggest the two cities were perhaps capital cities of larger superstates, one in the north and the other in the south of the Maya region. ■

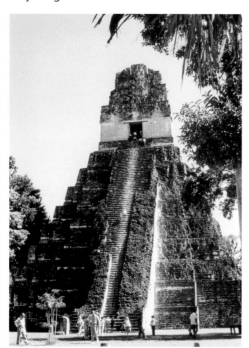

▲ *This pyramid made from regularly cut stones, which holds up the Temple of the Giant Jaguar at Tikal, Guatemala, rises 170 feet/51 meters above the plaza floor. It contains the tomb of King Ah-Cacau, who died in 734 A.D. after ruling the city-state of Tikal from 682 A.D.*

Wooden beams were placed ▶ *across a doorway in the Temple of the Giant Jaguar at Tikal by King Ah-Cacau's son sometime after 704 A.D. They are carved in low relief, and show the king seated on a throne wearing a headdress decorated with overlapping feathers and the face of the sun god. Behind the king, stands a giant jaguar with his fanged mouth wide open. The big cat acts as the king's protector. On the right is a small, simply dressed man standing before his lord.*

The Late Classic Maya culture (600-830 A.D.) found another use for pyramids. At least two of them, the Temple of Inscriptions at Palenque and the Temple of the Giant Jaguar at Tikal, contained tombs of kings in their bases. Both pyramids had nine levels, mirroring the Mesoamerican idea of the underworld. The pyramids not only represented the four directions of this world, but also joined the earth with the underworld and the heavens.

The Maya people believed that their king was not just an ordinary man. In life he was watched over by the gods and went into trances to talk to them. After his death, the king became a god himself. The stone buildings on top of the pyramids were temples where the Maya people worshipped their divine king.

The Maya thought their rulers were very important, even though their state was not as large as Teotihuacán. Vertical stone monuments called *stelae* showed the king with his divine protectors, often represented by animal forms. These *stelae* can still be seen in the central plaza at Tikal.

In the Late Classic period, Maya artists made the most beautiful art in all of Pre-Columbian America. The fluid style of the art can be seen in palace frescoes and on painted vases. All the figures have a flexibility of the body and the artists have captured surprising details.

A modeled stucco ▶ *head, from the tomb of King Pacal the Great in Palenque, was placed under his stone coffin when he died in 683 A.D. He began to rule the Palenque city-state in 615 A.D. This portrait head shows his bony face recognizable in many relief carvings.*

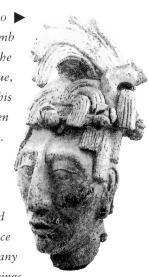

Ancient Writing _____

Around the tops of cylinder vases, on *stelae* and in manuscripts, the Pre-Columbian Maya left messages using hieroglyphs. No other Pre-Columbian culture developed a complete writing system: other Mexican cultures could write names and dates, but they could not write complete thoughts. No culture in South America has left clear evidence of written language. ■

A three-room palace at Bonampak, now a small ruined city in southern Mexico contains the only complete frescoes of the Classic Maya period. In the first room there is a fresco, above the raised platform where guests were entertained, of three male figures dancing. These figures wear jaguar-skin clothing which identifies them as royalty. On their backs they carry large, light-weight wooden frames that are covered with long, green quetzal feathers, plucked from the tails of living birds. In another section of the fresco, a line of finely dressed men motion to each other about the small boy being held up to them. They had been invited to recognize him as the future king.

Pacal the Great (603-683 A.D.), king of the western Maya city of Palenque, is buried below the Temple of the Inscriptions. His tomb is reached by a hidden staircase inside a tunnel in the pyramid. Thirteen different arches form the tunnel's roof, reflecting the Mesoamerican belief that the heavens had thirteen levels. Two plaster heads were found under the king's coffin. They were portraits of kings, perhaps taken down from the building they decorated before the tomb was sealed. Palenque royalty made the lines of their long noses going up into the forehead, longer artificially.

This is a reconstruction at the Florida Museum of Natural History, Gainesville, of room one of the palace at Bonampak. The reconstruction shows how the mural would have looked when they were completed after 792 A.D. On the right-hand wall the royal family sits on a large, four-legged throne. In the center is the crosslegged lord Chaan-muan. Behind him sits his wife painted in profile. A young princess stands on the ground overlapping the throne, giving the illusion of depth in the painting. ▼

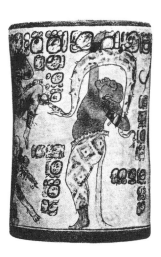

◀ *The date of this vase from a young woman's tomb in Altar de Sacrificios, Guatemala, is 754 A.D. The king of Yaxchilán is shown dancing in jaguar-skin pants. The king of Tikal (top left)* places drops of his blood in a jar as evidence of sacrifice. Below him, a man cuts off his own head while he vomits black bile.

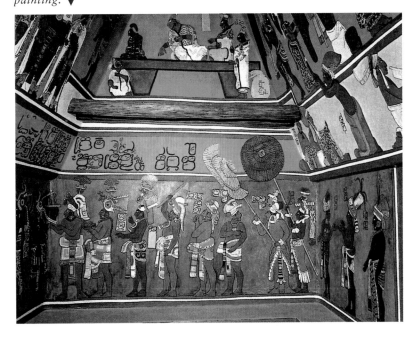

23

13 | The Toltec Empire, approx. 750–1150 A.D.

Integration Period

Political expansion became common for the states of Pre-Columbian America, beginning as early as 600 A.D. in the Andes and between 750 and 830 A.D. in Mesoamerica. Because the spread of power brought a unified artistic style throughout each empire, this is called the Integration period. It lasted until the European conquest between 1492 and 1538, in all of civilized America. ■

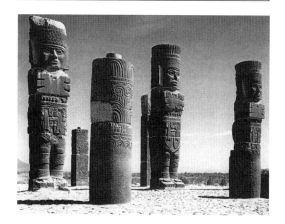

▲ *These stone columns, dating about 1000 A.D., represent warriors. They once supported the roof of The Temple of the Morning Star.*

The Temple of the Morning Star at Tula had ▶
a staircase built behind a hall of columns, which limited people's access to the pyramid's stairs. The roof of the temple on the top, was built around 900 A.D. and supported by columns of standing male figures, mostly warriors. The great columns show figures of ordinary men, not gods, carrying spearthrowers, weapons used by northern hunters. They hold bags of incense to please the gods.

The Toltec people claimed in their stories that they came out of a cave and hunted in the northern Mexican deserts. They moved around following their prey. When they encountered the civilized people of central Mexico, they conquered them and formed a military state. Small pyramids were built in the city of Tula, the Toltec capital, located on the northern edge of Mesoamerica. Tula grew quickly between 750 and 950 A.D., after the fall of Teotihuacán. Teotihuacán, the most important city during most of the Classic period, may have been burned and looted by the Toltecs. This, in part, caused its fall.

The Toltecs borrowed the carving style of Teotihuacán and other

Imperial Art

The term empire refers to a state created by the conquest of people by a more powerful people. An empire includes people who speak several languages and usually supports the creation of imperial art that celebrates the power of the empire. The conquered peoples in the Integration period were usually allowed to keep their kings. They had to pay tribute, however, to the king of the conquering people who then became emperor. Artists concentrated on the subjects of warfare and conquest. Large processions and battles were the images they portrayed in their battles. In Toltec carvings animals are used to represent people and, in particular, soldiers. Palaces and forts became important building projects, even in times of peace. ■

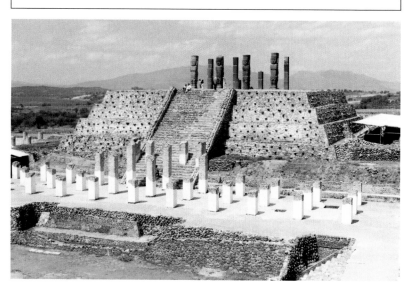

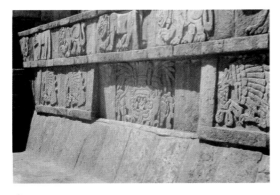

▲ *Low-relief carvings at the Temple of the Morning Star show at the top a line of jaguars and several coyotes, while those below show eagles picking at human hearts. The eagles and jaguars were the spirit guardians of the Toltec military societies. In the sunken center panel of the eagle frieze, human skulls look out of the open jaws of earth monsters. These images represent Venus, called the morning star. The planet Venus stood for death and rebirth to Mexicans and Central Americans.*

This is one of ▶ the two stone stelae six feet/ nearly two meters high, decorated with a figure wearing a headdress of feathers, that stood at Tula. The figure may represent a ruler. The carving resembles Maya works of about 900 A.D.

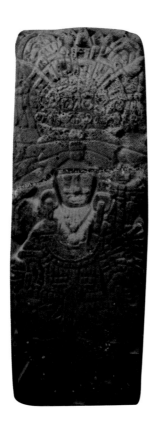

Mexican and Central American cultures. The details of their carvings are simple, but heavy in style. Toltec carvings emphasize the aggressive nature of animals rather than their beauty or grace. Toltec carvings also communicate the brutal military demeanor the empire's soldiers were expected to have. Imperial scenes decorate religious buildings and often show repeated lines of servants of the empire, represented as animals, threatening enemies. Like the warrior columns that support the roof of the Temple of the Morning Star, these aggressive animal figures protect religious buildings. In most early

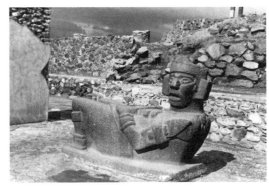

◀ *Sculptures of male figures like this one have been found near altars at Tula, Mexico. Sacrifices were placed on the plate on the figure's stomach. This carving was made of volcanic rock about 1000 A.D.*

Mesoamerican kingdoms military power was used for sacred war waged to take captives. The captives were sacrificed and their blood offered to the thirsty sky gods.

Columned palace halls with central open patios stand next to the temple at Tula. These were probably meeting places. Along the walls are wide benches decorated with reliefs showing processions of feathered male warriors. The design and geometric qualities of the figures are like the earlier Teotihuacán style, but they are roughly carved from pockmarked volcanic stone. Toltec sculpture is often painted directly on the stone rather than on a smooth stucco surface typical of Classic sculpture.

Toltec legends tell of the kings of Tula. The most important ruler was One-Reed Topiltzin Quetzalcoatl. One-Reed is his birth date in the ritual calendar. Topiltzin is his first name. The legends say he brought a time of peace and high culture to the Toltecs. He was eventually forced from Tula and fled with his followers to the east coast. They sailed east, across the Gulf of Mexico, on a raft of serpents.

Keeping Track of History_____

People who do not write must remember their history. Often stories or rhythmic chants that aid the memory are used to pass on the history to other people. When the Spanish arrived in the Americas, they wrote down these oral histories. Sometimes people use pictures and carvings to make a record of their history. This kind of written language is called hieroglyphics. ■

14 Toltec Art and the Maya in Yucatan, approx. 900–1200 A.D.

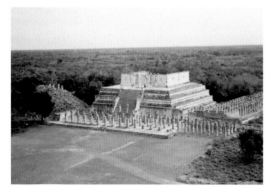

▲ *The Temple of the Warriors at Chichén Itzá is so similar to the Temple of the Morning Star at Tula that one must have been copied from the other. The large, standing figures there look like those at Tula and date about 879 A.D.*

At the Temple of the Jaguars at Chichén Itzá a fresco of the Toltec conquest of the Maya shows a battle raging near a group of small, thatched huts like those built by Maya today in the Yucatan. ▼

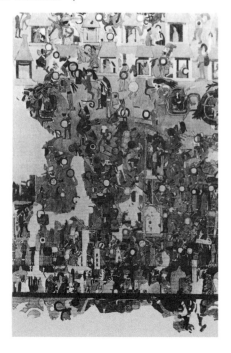

Across the Gulf of Mexico lies the Yucatan Peninsula. About the time that One-Reed Topiltzin Quetzalcoatl was leaving Tula to sail east, the people of the city of Chichén Itzá built a group of buildings near a large, natural well into which offerings were thrown. Many parts of these buildings were similar to designs at Tula. Buildings at Chichén Itzá were decorated with reliefs of eagles tearing at hearts, faces inside the jaws of earth monsters, and seated jaguars. All these creatures also appeared in the wall reliefs at Tula. Lines of figures were also carved in low relief along the bases of benches at Chichén Itzá.

The warlike nature of the people of Chichén Itzá inspired many of the battle scenes in painted low relief and fresco found there. Figures overlap slightly, creating a sense of depth in some scenes. As in all Pre-Columbian art, the figures are large and the colors just as bright even when positioned farther back in a scene. Battle scenes were designed like maps, with all the figures and objects represented as if seen from above. Each figure and object is illustrated in profile.

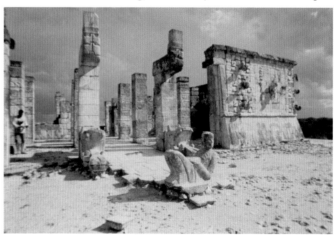

▲ *Figures like those at Tula were found at Chichén Itzá. They have more detail, angular knees and date about 1000 A.D.*

The League of Mayapán

The large Maya states broke into smaller states in the late Post-Classic period (1200–1500 A.D.). They came together again in the Yucatan peninsula under the League of Mayapán (1224–1461 A.D.). Stone walls made from rubble surrounded cities. These states probably felt threatened by their neighbors. ∎

15 Mixtec Painting in Mexico, approx. 1200–1350 A.D.

After the Toltecs, Mexico and Central America were divided into a number of small states, each feuding with the others. In the mountainous state of Oaxaca, the Mixtec-speaking cities formed kingdoms. Each king claimed a royal descent recorded in folded books painted on square-paged deerhide. The books often told of each family's ancestors and history. The figures in the books were outlined in flat, bright colors and placed in rough squares. The figures were squat with oversized heads. Their limbs and clothing made them look warlike.

In the multi-language region around the religious center of Cholula, the Mixtec Indians developed their illustration style found in ritual books. The illustration style spread to other cultures and appeared in other books, in architectural reliefs, pottery and fresco painting. It spread to the northwest Mexican frontier, opposite the tip of the Baja California peninsula, and south through the Maya area, into lower Central America as far as Costa Rica.

The Codex Zouche-Nuttall *is considered one of the finest Mixtec books. Painted in the fourteenth century* A.D. *it shows a Mixtec lord, with two warriors in boats at top right. At bottom right, two lords seal a treaty in a ballcourt.*

Metalworking Techniques

The technique of lost-wax casting allows artists to make hollow metal figures, which are lighter and use less material than solid figures. Mixtec artists used this technique. They sometimes modeled the layer of wax created in this process so that the final object looks as though it has fine openwork. Two pieces of metal can be joined together using a different molten metal that melts at a lower temperature than the pieces being joined. The Mixtec used this technique called soldering, to attach design elements, such as rings, to their works in metal. ■

A Treasure Trove

In 1932 a store of Mixtec treasures was found in a tomb at Monte Albán which the Mixtec had reused. More than a hundred gold, silver, pearl, rock crystal, obsidian and jade objects were found. It became clear that metalworking was another great skill of the Mixtec. ■

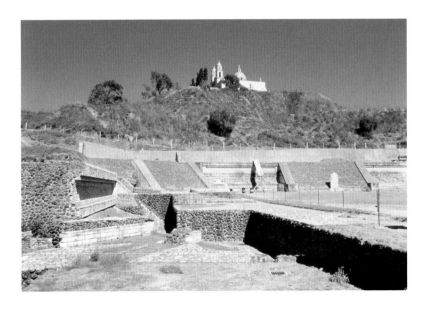

The main pyramid at Cholula was enlarged ▶ over an older, Classic structure during the Integration period. By about 1300 A.D. *it was the largest structure in all the Americas. A colonial church was later built at the top.*

The Aztec Empire, 1375–1520 A.D.

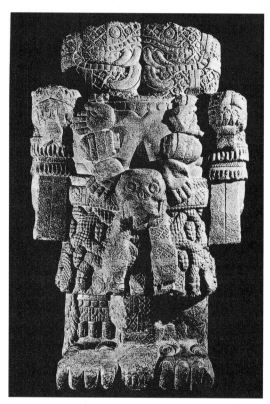

▲ *This is the stone idol of the Aztec goddess Coatlicue, the old goddess of the earth, carved in the capital city around 1500 A.D. The colossal statue of the goddess was discovered in 1790 on the site of Tenochtitlán's main square. Its great size (over eight feet/two and a half meters high) looms over the viewer and is overwhelming in its bulk. The goddess wears a necklace of human hands and hearts, with a central skull pendant, and her skirt is made of rattlesnakes. Her feet are claws that have eyes and her hands, which appear to be claws, are actually serpent heads with fangs that look like fingers. Her head is an optical illusion created by two serpents' heads that face each other. They symbolize blood spurting from cuts made by Coatlicue's children, the moon and the stars. They attacked her for being pregnant with the war god. Before they could kill her, the war god leapt from her womb and quickly slew both of them.*

The great capital city of the Aztecs, which they called Tenochtitlán, was more than twice the size of any Spanish city of the time. It was laid out on a small island using a grid plan. It is now located at the core of modern Mexico City. Causeways across a shallow lake connected the Aztec city to the mainland. The main avenues ran east and west and north and south. At the central crossroads was a ceremonial plaza surrounded by a wall with battlements. The plaza's base was guarded by a carved rope of intertwined serpents. The palaces of the Aztec emperors lay outside the walls of the ceremonial center. The walls divided religious activities from ordinary ones, and isolated the temples, in the same way that the columned halls in front of Toltec temples had done.

In the central walled enclosure, the great temple loomed over the sacred plaza. The great temple was made up of two buildings positioned side by side on top of one pyramid. One temple was dedicated to the Mesoamerican rain god, the other to the Aztec war god. Steep staircases lead up both sides of the pyramid. The bases of the balustrades (stone walls acting like banisters) are decorated with serpent heads. These balustrades rise to even steeper angles near the top of the staircases. The architecture stressed the dizzying climb and the awesome height of the gods. The colossal idol of the goddess Coatlicue stood on top of one of the temples within the sacred precinct. She was the mother of the war god, so she probably stood on that god's half of the great double temple. Spanish conquerors wrote about these idols, smeared with blood from the sacrifices performed on top of the pyramids.

Aztec myths are made to seem real through the skill of imperial

The Aztec Empire_____

The biggest Pre-Columbian empire north of the equator in America was created by the Aztecs. They had a legend of migration which was similar to the Toltec's. The Aztec empire was much smaller than Mexico is today. People conquered by the Aztecs paid tribute, often with products from their homelands, which were recorded in documents probably copied for the Spanish by Indian scribes. Seven thousand tons of maize and two million cotton cloaks, it was recorded, came from towns required to pay tribute. Labor was also required of conquered people, to help build large public works such as temples, aqueducts or roads. ■

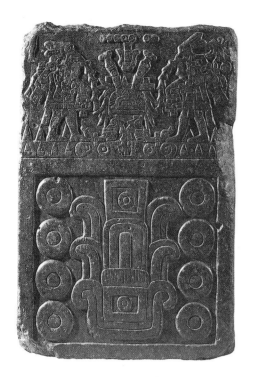

▲ *The Aztec emperor Tizoc who ruled from 1481 to 1486 A.D. in central Mexico is pictured on the upper left of this temple dedication stone, found at Tenochtitlán. On the right is his brother Ahuizotl, who succeeded him as ruler from 1486 to 1502. They stand on the symbol for the earth. They are using thorns to draw blood from their ears. The blood flows into the sacrificial hole in the earth below. They are identified by the hieroglyph behind each head.*

This royal headdress, made of green quetzal tail feathers from an area near Guatemala, came into the possession of the Spanish after their conquest. ▼

Spanish Conquest_____

Hernán Cortez (1485-1547) landed in 1519 on the Gulf coast near Veracruz, Mexico, where he made allies with the Totonac Indians. The Totonac were tribute-payers of the Aztec and hated their tax collectors. Cortez and the Totonac allies formed an alliance with the Tlaxcalans, who had successfully resisted Aztec demands for tribute. With these two groups as allies, the few hundred Spaniards managed to bring down the mighty Aztec empire in 1521. The Aztecs feared Cortez was the bearded Toltec king, One-Reed Topiltzin Quetzalcoatl, returning as he had promised hundreds of years before. ■

artists. The crude style of Toltec sculpture disappeared even though many Aztec sculptors used rough, volcanic rock. Finer carving and the use of three dimensions set Aztec sculpture apart, and makes a powerful statement of imperial might.

Colonial books painted by Indian artists have many images of the Aztec emperors, but royal portraits are very rare in Aztec art before the European conquest of the early 1500s. In those few examples where the ruler is shown, he is identified by hieroglyphs of his name placed near his head. On the stone of Tizoc, the emperor wears a more elaborate feathered headdress than the other warriors represented. This was to remind viewers of the war god, whose name means "hummingbird on the left." A similar huge feathered headdress (pictured on the left) has survived since the conquest. It can be seen in the Museum für Völkerkunde in Vienna, Austria. It may have been given to Cortez by the Aztec emperor Moctezuma.

Wheels _____

In Pre-Columbian societies enormous loads of building materials were carried on the backs of workers. No beasts of burden or wheeled vehicles were used. The Aztecs and earlier peoples of the Gulf coast knew about wheels, but only used them for toys. ■

This little Mesoamerican clay animal toy can be moved ▲ *around on its wheels. The design is similar to toys made today.*

17 Imperial Art at Tiwanaku, approx. 400–1000 A.D.

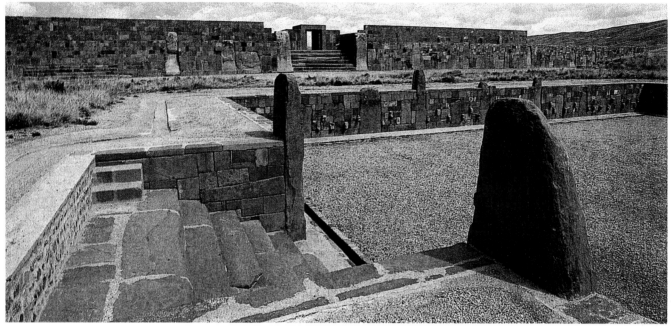

▲ *The half-sunken temple courtyard at Tiwanaku was built with evenly cut stone walls and projecting, human, stone heads representing the trophy heads from conquered areas. It was built about 400 A.D., but all the stone heads were not added to the walls until after 600 A.D.*

The Wari Empire

Several hundred years after the beginning of the Tiwanaku state, and well to the north of it, in the central highlands of Peru, another empire centered on the city of Wari began to grow. It established outposts throughout Peru, collecting, storing and redistributing tribute from its subject peoples. These outposts were connected by a system of highways which remained and were expanded long after the fall of the empire that built them. The Wari empire was independent of Tiwanaku, but its artists copied the Tiwanaku style because of its great religious importance, and spread the designs throughout the area it controlled. ■

In the central Andes, far away from the Aztec empire, imperial art began to be made about 400 A.D., on the high plateau of modern Bolivia at Tiwanaku. The stone temple at Tiwanaku, similar to the Formative-period temple at Chavín de Huántar, has heads projecting from the walls.

Opposite the half-sunken courtyard rises a large, artificial mound, originally a pyramid, which had a pond built on the top. Its water was channeled down the sides into a moat around the main buildings. In the rulers' reception palace, there are colossal stone sculptures of male figures with incised patterns on their clothing and skin. They may be rulers acting as priests and dressed as gods.

A relatively small, isolated, ornate gateway made of a single block of stone stands within the enclosure. Called the Gate of the Sun, it may have been a kind of annual solar calendar. It is decorated with carvings of a shining god on a mountain top. On either side are six processional rows of winged human and bird-headed figures. Parts of these carvings were copied by artists working for the Wari empire who spread Tiwanaku imagery to most of Peru.

Empires of the North Coast of Peru, approx. 850–1470 A.D.

El Ninõ

Coastal Peru is very dry because the cold Pacific Ocean water evaporates and does not fall as rain until it hits the high Andes. Only rarely, around Christmas time, does the water warm up causing heavy rains. This weather is called El Ninõ, the Spanish name for the Christ Child. The rains El Ninõ brings have done terrible damage on the Peruvian coast. The early Moche and Lambayeque kingdoms are thought to have collapsed because of El Ninõ's disastrous floods. ■

Near the end of the Wari empire, a new kingdom rose up on the north coast of Peru. The culture is best known as Lambayeque, after a modern town near the center of the region, which has been renamed Sicán. Legend has it that this dynasty was founded by King Naymlap, who sprouted wings, flew off and disappeared. The story reinforced the common belief that kings were divine. The art produced by the Lambayeque culture used imperial images.

The Chimor, who lived further south, overran the Lambayeque kingdom after 1200 A.D., and created a large empire on the Peruvian coast to the north. They traded with the people living in the Peruvian interior and on the Ecuadorian coast. Their royal art was like that of the Naymlap dynasty. Brightly colored feathers from birds of the Amazon were used in the colorful textiles produced by the Chimor. The textiles were made with repeated patterns of warriors, sometimes arranged in step patterns like pyramids. This pattern symbolized imperial control of the mountains. The figures resemble those found in other imperial art. There are similar figures supporting the figure of the king found in recesses along the entryway to one royal enclosure at the Chimor capital of Chan Chan.

There are ten great enclosures at Chan Chan. Each belonged to a different emperor. High mud brick walls kept out ordinary citizens, and reinforced a battle attitude, at the heart of the empire. Those who were permitted access, walked through narrow, roofless corridors into a large ceremonial space. Beyond this area were interview rooms and living spaces, a reservoir and a pyramid for the emperor's burial. At his death the enclosure was sealed and became a shrine to the new god.

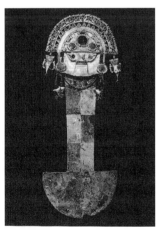

◀ *Cast in gold and inlaid with turquoise about 900 A.D., this Lambayeque knife with a crescent blade, has a figure on its handle said to represent King Naymlap.*

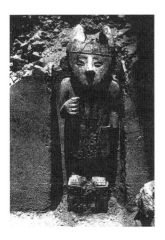

◀ *A recess in a wall at Chan Chan holds a wooden figure wearing a kilt and a peaked hat. It is probably a portrait of a royal family member, carved in the early 1400s.*

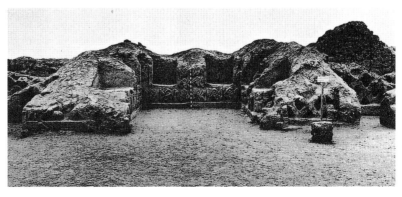

▲ *This Chan Chan citadel was built in the 1400s for the emperor's family. It provided offices, a place for ceremonies and a tomb for the emperor.*

19 The Inca Empire from Chile to Ecuador, 1427–1532 A.D.

The Incas created the greatest empire in the Americas before the European conquest. Theirs was an authoritarian society. The wishes of individuals were of little importance to the rulers. To make the empire more secure, they moved around entire populations they conquered, splitting apart families and friends, to weaken their sense of security. The children of conquered rulers were brought to the city of Cuzco to be educated like Incas. Everything the Incas made or grew was collected and stored in enormous warehouses and officials decided on distribution. The system was so good that there were no famines.

The rigid Inca empire imposed artistic unity over the vast territory they controlled. Necked storage jars with geometric designs were used everywhere. Standard cloth and figurine designs reduced variety. Even shirt designs were standardized to establish the status of the wearer.

Architecture was much less rigid than other arts of the Incas. Walls of buildings were made of huge stones cut to fit in place

▲ No mortar was used to hold together Inca walls. Their strength is proven by the fact that many still stand, like this wall recently photographed in Cuzco, Peru.

▲ This piece of woolen textile from the coast of Peru has figures in its design like those found in Chimor designs.

The Inca Empire

The Inca empire originally centered around Cuzco, Peru. Through conquest the empire eventually encompassed all of modern Peru (including the Chimor empire) and most of Bolivia, Ecuador, the northern half of Chile and northwestern Argentina. Conquered peoples were forced to speak the Inca Quechua language. Ten thousand miles/16,000 kilometers of roads, some built by the Wari, linked distant cities. Relay runners used the roads to carry messages. The Incas had no writing system. They used knotted cords on strands called *quipus* to keep records. They worked like abacuses. The runners carried verbal messages and used *quipus* for secret, coded messages. ∎

Precious Metal

The Incas and other Andean peoples considered gold and silver sacred. They called gold "sweat of the sun," and silver "the tears of the moon." These metals were admired for their symbolic color. They were used by artists to make symbols and the images of gods. A leader who wore objects made of gold or silver was believed to be connected to the gods. The Spaniards, on the other hand, saw these metals as a source of wealth, and melted down the beautiful objects they found so they could weigh the metal easily and transport it back to Spain. ■

precisely without using mortar to hold them together. They were usually cut to a regular, rectangular shape, but sometimes unique stones were cut with many sides and angles, and fitted in place in the structure by rubbing the top stone against the bottom ones. Many of these stones have bulging surfaces that give the stones life, almost as it they were breathing creatures instead of rock. Some stones were enlivened with small creatures in low relief, carved as if they were skittering across the stone surface. Many Inca walls still stand.

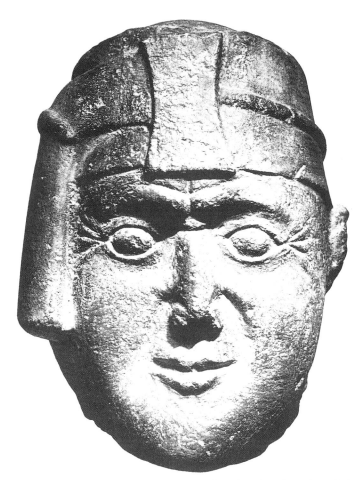

▲ *The stone face of an Inca emperor was found under the colonial church of La Compañía in Cuzco. Strong character is suggested by the deep, animated wrinkles around the eyes and mouth. The figure wears the emperor's headdress and tassel of royalty. This large head must have once been part of a full statue of the emperor made around 1500. The Incas believed their royal family was divine because it descended from the sun god. The large size of the sculpture suggests the political power this man had.*

◄ *An Inca child was sacrificed on a mountain top above Santiago de Chile and buried with this small, silver figurine dressed in colorful feathers.*

Spanish Conquest

The Spanish conquistador, Francisco Pizarro (approx. 1475–1541) heard stories about a land south of the Caribbean rich in gold. He went to Peru in 1531 and found the once great Inca empire, weakened by rebellions and wars of succession. Pizarro made alliances with local factions and captured the Inca ruler, Atahuallpa, in Cajamarca in 1532. The Spanish held the Inca ruler for ransom. The ransom filled a room, which still stands in Cajamarca, with gold and silver. After the ransom was delivered, Pizarro's men choked the emperor to death. Pizarro worked to build new empires after the death of Atahuallpa. After 1535 he founded Lima and other cities in South America. ■

20 Pre-Columbian Influences in a Post-Columbian World

The time before Christopher Columbus landed in the Bahamas, Cuba, and Hispaniola (now Haiti and the Dominican Republic) in 1492 is called the Pre-Columbian period. After the conquest of the Inca and Aztec empires the Spanish focused on building settlements where the Incas and Aztecs had lived. Both the conquered empires had long traditions of producing fine art in many materials and both had made stone buildings. By the mid-1500s the Spanish had gained full control of these areas and they became the viceroyalties of New Spain and Peru.

Before the conquest, artists in the high civilizations of Mexico, Central America and the Andes generally worked full time at one craft. Different Indian cultures had developed specialized artistic skills. Large-scale building projects had given workers opportunites to develop skills in stone-cutting and relief-carving. The great variety of works of art attracted the attention of the Spanish.

Aztec centers in the highland towns of the viceroyalty of New Spain continued to produce the finest stonecarving in the round in Mexico in the 1500s. After the conquest, Indians applied their skills to making European images.

The Spanish Laws of the Indies, drawn up in 1573 and revised in 1671, to provide guidelines for new colonies, recommended that grid planning be used to build new cities. The Aztecs built rectangular cities with streets and canals meeting at right angles. Colonial maps drawn follow Pre-Columbian conventions and show bird's-eye views of towns with small houses. Inca methods, similar to Spanish traditions, were used to build the new cities. Plaster reliefs on local adobe walls provided models for the busy carved surfaces of colonial buildings.

◀ *Indian carvers, on Spanish orders, made this stone lion about 1550. It is part of a fountain in Tepeaca, Puebla, Mexico and looks like an Aztec coyote. Water could flow from the hole in its mouth.*

Burying Indian Traditions_____

The Spanish and Portuguese conquests of America caused political change and brought cultural change. Many Indian traditions became buried in European civilization. This cultural conquest was almost total among the nobles in native civilizations. Among the ordinary people, cooking customs survived, but they began to use new plants and animals introduced by their European conquerors in their cooking. Most Indian customs of dress survived but imported European cloth began to be used. ■

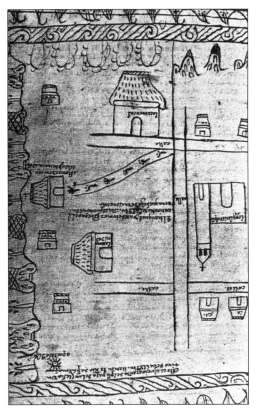

▲ *In 1579 Spain's King Philip II asked for a report concerning the history and geography of his new colonies. An Indian draftsman trained by the Spanish drew this map of the settlement of Misantla in New Spain. The draftsman used ink on European paper instead of Pre-Columbian fiber or deerskin.*

▲ *The weaving of hats, mantles, shawls and sashes continued among Indian groups in the Andes long after the conquest. The designs of these shawls made recently are similar to patterns dating back to Inca times.*

No Pre-Columbian Aztec books survive but the *Codex Borbonicus*, made by Aztecs for their conquerors, shows what Aztec books were probably like. Its scenes of Aztec rituals fill the entire page. This Pre-Columbian skill and others began to be used for Spanish patrons.

In the Pre-Columbian Andes, woven cloth was used for trade and indicated social status. The highland Indian towns of Ecuador, Peru and Bolivia still consider textiles important. Textile and ceramic decoration changed in that animal motifs with religious associations were replaced by decorative plant forms.

Other Indian crafts in the central Andes declined. Metalworking skills once used to make gold and silver religious images, were used for decorative silver work. Indian woodcarvers made church pulpits, choir stalls and altar pieces, rather than Pre-Columbian figures.

◀ *The tradition of folk pottery continues to this day all over Latin America. In some Indian towns pottery is made by entire families who work at the craft. Towns like Tlaquepaque, near Guadalajara, Mexico, have become major centers for the sale of many crafts to tourists. Tlaquepaque's pottery is now shipped all over the world.*

Inca Walls

The city of Cuzco still has many remains of Inca stone walls, laid without mortar, preserved in the walls of the buildings built for the Spanish conquerors. Indian labor no doubt was used to make these later additions. ■

This Inca wall in Cuzco was raised to a ▶ second story by the Spanish. Baroque doorways were added.

21 Spain, Portugal and New World Art

The Moors

The Moors were Muslims who came from what is now North Africa. In the eighth century A.D. they conquered most of Spain and Portugal and moved on to try and conquer France. They were turned back at Tours in central France in 732 A.D. by Charles Martel (approx. 688-741 A.D.), but seven hundred years passed before the Moors were expelled or converted to Christianity and all of Spain and Portugal were reconquered by Christians from Portugal and the Spanish kingdoms of Aragón, León and Castile. ■

▲ *This patio of a private home in Jerez, Zacatecas, northern Mexico, shows the survival of the Moorish emphasis on interior garden spaces. The exterior of the house is right on the street and the patio garden is hidden inside.*

Europeans colonized the new world to gain economic and political power, and they took their Roman Catholic religion with them. They felt it was their duty to spread Christianity wherever they went. Religion held an important place in Spanish and Portuguese thinking and it underlies almost all the artistic ideas these Europeans brought with them.

Ideas from four major art traditions were imported into the Americas with the conquest. These were the Moorish art traditions, Reconquest architectural style, northern European book illustration, and the design principles of the Italian Renaissance.

The Muslims, called Moors, who conquered Spain in 711 A.D., built houses around interior courtyards or patios. The style exaggerated the difference between the blank exterior walls of the house and the sheltered garden in the courtyard in which the Moors created a lush paradise a little like a desert oasis. Decorative woodwork was often used and pieced together in complicated geometric designs. Brightly colored tiles with floral designs covered floors and the lower parts of walls. Many of these features were taken over by the Spanish and Portuguese in their buildings when the Moors were eventually driven out of their countries. These ideas were taken to the American colonies where even today private homes can be found that have the same lush interior patios.

The reconquest by the various Spanish kingdoms and Portugal of the area controlled by the Moors, from about 1000 to 1492 A.D., led to a taste for military appearances. Large buildings were constructed with walls that looked fortified from the outside. In many cases the battlements were only ornamental. The plans of new towns in the reconquered territories took the rectangular grid form of a Roman military camp. Major streets crossed at right angles in a central square. This sort of plan was taken to the Americas, where similar

The New Oil Paints

Nobody knows for sure when oil paints—ground pigments mixed with oil—were invented. They came into common use during the Renaissance. Artists using oil paints had richer colors and a wider range of color tones from light to dark at their disposal. The Spaniards took oil paints with them to the Americas and produced dramatic paintings. Oil paint helped European artists bring Christian faith to life for the Indians in religious paintings. ■

▲ *This woodcut decoration is from a page of a book published in Seville, Spain, in 1535 entitled* General History of the Indies, *by Fernández de Oviedo. It is the sort of Mannerist decoration that was adapted, and often misunderstood, for use on colonial church doorways and in murals.*

Printed Models

The wood engravings brought to the new world by the European religious community also influenced art and architecture after the conquest. Artists used the decorations of book title pages, border designs and simple line illustrations as models. From them they created decorative elements for new buildings, designed entire church facades and painted huge religious frescoes. These engravings were the inspiration to artists of every discipline and helped build a new art tradition. ■

ideas about city planning already existed particularly among the Aztecs.

The Hapsburg King Charles I of Spain who later became the Holy Roman Emperor Charles V (1500–58), came to the throne in 1516. He brought to his court artists from Flanders, another Hapsburg possession now part of Belgium. They were wonderful painters who used recently invented oil paints—a mixture of pigment with linseed oil. In the 1400s the Flemings sent paintings to Spain and Portugal framed as altarpieces. Flemish and German artists also made engravings and woodcut prints to illustrate religious books, and later, reproductions of important oil paintings. Book decorations, especially on title pages, suggested architectural decoration to the friars who went to the Americas.

The rebirth of Greek and Roman ideas and art styles of the Renaissance in Italy in the 1400s reached Spain in the 1500s. Naturalistic representations of human beings, animals and landscape were copied from ancient works, as were Roman theories of architecture. These ideas were taken to the new world, but the Renaissance emphasis on fine proportion and the logic of load and support were often ignored by colonial artists and architects. In painting, Italian Mannerism had the greatest influence in Spain and Portugal during the 1500s, and also in Latin America. The Latin-based Spanish and Portuguese cultures and languages became most important in the new world in the 1500s.

◄ *The entrance of the Franciscan monastery at Tecali, Puebla, central Mexico, built in the 1500s, has a classic Renaissance arched doorway surrounded by fluted columns.*

22 Early Colonial Architecture, approx. 1500–1540 A.D.

First Colonies

Christopher Columbus founded his first new world settlement in 1492 on the Caribbean island of Hispaniola. Today the island is occupied by the states of Haiti and the Dominican Republic. In 1493, Columbus found that this settlement had been overrun by natives. So he founded another colony in the northeast part of the island. In 1502, Coumbus's brother, Bartholomew, established yet another settlement on the south coast at Santo Domingo, the capital today of the Dominican Republic. Disorder and tension between the settlers and the Indians weakened the influence of Columbus's family in Hispaniola and led to the Spanish government taking direct charge of the colony. ■

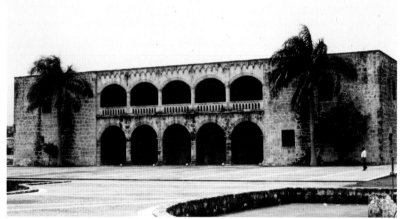

▲ *The palace of Diego Columbus (1480-1526), son of Christopher and governor of the West Indies, was built in Santo Domingo, around 1510. It has heavy walls with battlements, and opens on both stories to graceful arches enclosing porches overlooking the river and the city. The building combines the medieval military style of the Reconquest with the grace of the Italian Renaissance, although some details are late Gothic.*

The first European settlement that provided more than basic shelter, Santo Domingo, was fixed at its present location on the island of Hispaniola in 1502. The plan of the city was a grid slightly altered by the irregularity of the sloping site. Today Santo Domingo, the capital city of the Dominican Republic, has many carefully restored buildings. Some of these buildings have Gothic-style details in their stone window frames. Doorways, such as the north entrance to Santo Domingo's cathedral, have small, slender columns supporting ribs, and interior ribbed vaulting. Vaulting throughout Latin America used Gothic-style ribs until the 1600s, although this type of ceiling construction was no longer used in Spain during the 1500s.

The earliest religious buildings in Mexico were built by Indians under the direction of Catholic friars. By about 1550 they were using the Plateresque style. This architectural style took its decorative elements from lavishly ornate candelabra, serving platters and other objects produced by sixteenth century Spanish and Portuguese silversmiths. The clear, load-bearing shafts of Corinthian columns, for instance, were decorated with carved sashes and details that look like stacks of pots placed at the column bases. The rich exterior decoration of many churches was similar to Pre-Columbian design, incor-

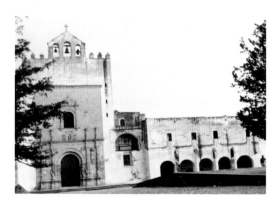

▲ *The monastery and church of Acolmán, Mexico, was built for Augustinian friars between 1539 and 1571 by Indian converts. The main entrance is decorated with beautiful Plateresque ornament. The high walls are like those of Reconquest fortress churches built in Spain and Portugal.*

Friars

Members of Roman Catholic religious orders were sent to live among the Indian peoples of Latin America to convert them to Christianity. They were called friars, from a Latin word for brother. They came from many European countries and belonged to the Franciscan, Dominican and Augustinian religious orders. They lived humbly among the Indians and learned their languages. Converting the Indians and offering them protection was their duty. They kept an accurate written record about beliefs and ways of life, often written in Indian languages, that has been of great value to historians. ■

▲ *This stone crucifix mounted on a high base, was carved by an Indian workman around 1550 at the monastery at Acolmán, Mexico, Christ is represented only by the image of his face at the center of the cross.*

porating closely spaced, low-relief, used by both Mixtec and Maya architects. The high, wide, arched space inside the buildings was breathtaking when compared to the enclosed spaces of Pre-Columbian buildings that had narrow rooms or forests of stubby stone columns.

Through the friars' work, large numbers of Indians converted to Christianity. Room had to be found for them for religious observance. In Mexico, large, enclosed courtyards called atriums were built to solve the problem. Similar spaces are found in Italian churches built around 400 A.D. Rectangular atriums, enclosed on all sides by walls and shrines, focused on the high fronts of the churches. They were like Pre-Columbian four-sided plazas, where people stood to watch ceremonies at the top of a pyramid. The friars tried to relate the new religion of Christianity to the kind of religious experience the Indians had known by using the same kind of ceremonial space. Some churches were even built on the ruins of pagan temples.

Instead of the low altar usually placed in the center of Pre-Columbian plazas, Christian atriums had a large crucifix mounted on a heavy, square base. The figure of Christ on the cross was carved in flat, raised relief just like Pre-Columbian carvings. The sculptors communicated through symbols, as the Indians already did, rather than realistically.

The white plastered walls of cloisters attached to the churches were painted with murals. Murals, often painted only in black on the white surface, look like blown-up versions of European prints, very popular in the 1500s. Some of the murals may have been painted by friars, although the confused lettering and geometric conventions suggest Indian workmanship.

The Cult of Guadalupe

The Mexican cult of the Virgin of Guadalupe is an example of how Christianity and Aztec religious beliefs came together. In 1531, after the Spanish conquest, it is claimed that an image of the Virgin Mary, the mother of Christ, appeared to an Indian called Juan Diego at Tepeyac, just north of Mexico City. Tepeyac was a place sacred to the Aztec earth-mother goddess, Tonantzin. Diego claimed the Virgin requested a church be built there. When Diego's claim was ignored by the Spanish bishop, the Virgin's image was miraculously imprinted on Diego's Indian fiber coat as proof of her presence. The vision of Juan Diego was then accepted and a church was built at Tepeyac which became known as Guadalupe. It is the national shrine for all Mexicans. Banners bearing the Virgin's image were used by Mexicans in their first bid for independence from Spain in 1810. ■

23 Mannerist Art, approx. 1540–1640 A.D.

This ▶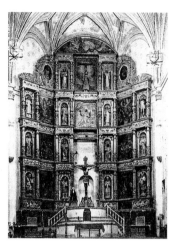
altarpiece in the monastery church at Huejotzingo, Puebla, Mexico, built in 1586, is an example of the cooperation required to successfully complete such a large-scale project. Eight paintings by the Mannerist, Simón Pereyns, are mounted in wooden, architectural frames. Fourteen figures, carved in wood by Luis de Arciniega in high Renaissance style, are included. A gilder applied the gold leaf and painted the enameled skin tones and the clothing of de Arciniega's figures.

Conflict of Interest

The Catholic friars enthusiastically and sincerely tried to convert the Indians. Their defense of Indian rights was not appreciated by Spanish colonial leaders, whose main concern was to gather the riches of the new colonies. This conflict in aims and an increasing demand within the Catholic Church for standardized religious practices (which the friars in Latin America had changed to appeal more to traditional Indian religious traditions) caused the friars' influence to lessen by the late 1500s. New religious men were sent to replace the friars and to make sure that all Latin American Catholics adhered to strict practices dictated by the Spanish church. ■

The Mannerist style of the late Renaissance in Italy was the first to be transferred to the new world. Latin American artists copied idealized designs in the exaggerated Mannerist style introduced to them in pattern books used by European furniture designers and architects. New world monasteries, for instance, were decorated with fantastic variations of Roman frescoes, which had been unearthed in the later 1400s, sketched by European artists and reproduced in these books.

By the late 1500s the political authorities used Indian artists much less for important work and began to use professional, European artists to complete commissions involving religious subjects. The Fleming Simón Pereyns (approx. 1530–89) arrived in Mexico in 1556 to paint altarpieces. These enormous works demanded cooperation among painters, sculptors, carpenters and gilders, no easy task in colonial Latin America. A great number of altarpieces were commissioned and completed during this period.

The viceroyalty of Peru attracted notable European artists like Bernardo Bitti (1548–approx. 1610), an Italian Jesuit who came to Lima in 1574. His works are found in the highlands of Arequipa and Juli in Peru and in La Paz, Bolivia. By 1587, he was working in Ecuador. His works have Mannerist line, proportion and color.

The greatest Mexican Mannerist painter Baltasar de Echave Orio (approx. 1548–1620) left Spain in 1580, when the Italian and Flemish Mannerist styles were the international standard. Echave Orio headed a group of artists in which traditions, starting with the Mannerist style, were passed on from father to son and teacher to student for about 150 years. European style was maintained while a Mexican painting tradition developed.

◀ *The Virgin of the Candelaria was painted in oil on cloth by Bernardo Bitti in the late 1500s. Bitti was an Italian Jesuit who moved from monastery to monastery creating these large works. The size of most of the surviving paintings by Bitti suggest that they were meant to be included in altarpieces. But the wooden alterpiece frames have been replaced by Baroque gilded frames in later centuries.*

24 Purist Architecture, approx. 1580–1650 A.D.

Philip II of Spain

Philip II succeeded his father Charles I as king of Spain in 1556. Spain's possessions then included the Netherlands and Spanish America. In 1588, after England aided the Netherlands in its rebellion against Spain, and the Englishman Sir Francis Drake had sacked the Spanish port of Cadiz, Philip II sent his navy, the Armada, to attack England. The Armada was defeated by the English navy and subsequently by storms. ∎

▲ Huge corner towers frame the low, broad front of Lima cathedral. Built between 1598 and 1604, it was designed by Francisco Becerra.

The first great cathedrals in Latin America were built by the Spanish in the century before 1650. These buildings were spacious inside and austere outside. There design did not include the atriums built in earlier churches to accommodate the large number of Indian converts to Christianity. In fact, by 1600 the Indian population had been reduced to only one tenth of its original number due to ill treatment and infection from European diseases, such as smallpox.

The plans for the first great cathedrals were symmetrical. This type of design was introduced by Juan de Herrera (1530–97), whose works were very popular in Spain. His Mannerist style, called Herreresque or Purist, shows a preference for beautiful form through its simplified design which used rigid symmetry and repeated proportion.

Another architect, Francisco Becerra drew up the plans for the cathedrals of Mexico City and Puebla in Mexico and those of Lima and Cuzco in Peru. The exteriors of these cathedrals have long walls interrupted by heavy buttresses designed like flat columns. Towers of equal height stand at the front corners. Correctness of symmetry was the goal of de Herrera and Becerra. The Purist architects reflected the severity of Catholic civilization in Philip II's (1527–98) Spain.

The plantation system was ▶ *developed to supply the demand for sugar in Europe. Labor came first from local Indian inhabitants and later, Africa. This is a scene of Brazilian slave labor.*

A New Religious Straitjacket

When the Spanish conquest began in the Americas, the Spanish had either driven the Muslims out of southern Spain or converted them to Christianity. In addition, Spain also forced its strong Jewish community to convert or be expelled. Any threat to the security of Spain and the power of the king was treated very harshly. Differences in religious thought and belief were seen as threatening. Philip II was a devout Christian. He was determined to stamp on any religious ideas and practices which were different from the teachings of the Catholic Church. Through the Spanish Inquisition the Church and government of Spain rigidly enforced acceptable beliefs and practices not only in Spain but also in the new world. The friars' adaptations to make Christianity more acceptable to the Indians and the use of Indian converts to make important religious art were forbidden. Some colonists were even investigated to see if they were Jews or Muslims. ∎

▲ *Except for Christ and a figure on the upper left (perhaps the artist's self-portrait), López de Arteaga painted in oil ordinary men in* Doubting Thomas *of 1643.*

▲ *This painting commemorated a Corpus Christi procession during the 1600s in Cuzco, Peru. The Master of Santa Ana used the large scale and bright color of the Flemish painter Peter Paul Rubens to depict what may be the first scenes showing a contemporary Latin American event. In this painting we can see all segments of colonial society.*

The Italian Baroque style of painting spread to Seville in Spain and from its port reached the Americas in the mid-1600s. It appeared suddenly in Mexico with the large, dramatic and shocking canvases of Sebastián López de Arteaga (1610–53).

The work of Flemish painter Peter Paul Rubens (1577–1640) was also an important inspiration to Latin American painters of this period. His influence softened the shocking realism of earlier Baroque art, but kept its large-scale figures and natural skin tones and added rich colors.

Many civil officials in Latin America at this time held only temporary appointments, so they were not in a position to give many commissions for works of art. Church authorities commissioned most works of art in the mid-1600s. Altarpieces and enormous paintings of religious subjects that filled entire walls were commissioned. The best examples are the works of Cristóbal de Villalpando (approx. 1652–1714). His paintings of religious scenes cover the walls of the sacristy of Mexico City's cathedral. His paintings in oil on canvas were hung on the walls in arched frames that curved like the ceilings above them. In 1688, he painted the dome of Puebla cathedral with one large scene of angels and saints among the clouds reaching up to the Dove of the Holy Spirit inside the brightly lit cupola.

The fine, balanced Renaissance carving of wooden sculptures, produced by sculptors such as Luis de Arciniega in the 1500s, was replaced by more active, aggressive carvings. Some works by Spanish sculptors, like Martínez Montañés (1568–1649), were shipped to the Americas from Spain. They are life size and realistic. Sculptors chose emotional moments in the Passion of Christ as subjects for their work. The realism of the images, often attired in actual garments, is forced on the viewer.

During the Baroque era, provincial church fronts and interiors

Art to Reinforce Belief

Latin American painters were trying to capture the emotions and hearts of their viewers and communicate some of the enthusiasm behind the Church's mission. To do this they painted in a grand manner, portraying richly dressed people, striking dramatic poses and setting their characters in sumptuous scenes. ■

▲ *This standing life-size wooden sculpture of St. James was made in Ecuador by Father Pedro (active 1620–80) and painted with many layers of colors over gold leaf.*

Putting on the Flesh

Sculptors also wanted to reinforce religious belief through their realistic, life-size statues. The sculptures were often dressed in real clothing and would be carried on the shoulders of the faithful at religious festivals. The sculptors made their work as real as possible by "putting on the flesh." This meant painting translucent layers of paint on the wooden surface so that it looked like human skin. Gold leaf was then applied to the carved clothing and colors were painted over the gold leaf, to achieve the look of rich, gold-threaded tapestry. ■

were built to look complex and forceful. The surfaces were heavily ornamented. A two-level relief was often drilled into the surface of a building. This made the reliefs look like screens. Pre-Columbian stone and woodcarvers had made similar two-level reliefs. The southern Peruvian and Bolivian highlands, southern and western Mexico and Guatemala, where most churches like these were built, had been centers of Pre-Columbian Indian civilization. Here there was still a significant Indian and *mestizo* or mixed Spanish-Indian population. This style became known as *Mestizo*.

Mestizo origins have also been attributed to the painted and gilt stucco work in southern Mexico. The surfaces of vaults, domes and vertical walls were filled with figures of angels. Small flowers and figures overload the eye and make the stuccoed surface vibrate with a riot of color and high relief modeling.

Portuguese Brazil

Portugal is a small country which had major colonies in Africa, India, Indonesia, and south China from the early 1500s until the twentieth century. It did not pay much attention to its small colony in Brazil. Its few settlements during the Baroque period were scattered along a 4000 mile/6000 kilometer coast. The Dutch took some of the Portuguese land in Brazil in the 1630s and formed their own, much more prosperous colony, called Bahia. Brazil was never a self-governing viceroyalty the way New Spain and Peru were, but depended on the mother country. Brazilian art is much like Portuguese art of this period because of the continuing tie with Portugal. ■

The Jesuit church of ▶ La Compañía in Arequipa, Peru, is decorated in the Mestizo *style. This is the central doorway of 1698, where all the surfaces but the columns are densely decorated with flat floral designs and half-figure human supports. These design elements were copied from Mannerist prints and book decorations.*

Mining Prosperity

The colonies of Latin America have always been used as a source of precious metals. The original conquerors wanted gold and silver to make their fortune, although the Spanish crown demanded one fifth of their take. The hill of Potosí in upper Peru was such a rich source of silver that it financed Spain's international activities for over a hundred years beginning in 1550. Rich mines in northern Mexico helped fund beautiful churches. In Brazil, gold was discovered in the late 1600s and diamonds in the early 1700s. Both financed the building of inland colonial towns such as Ouro Preto ("Black Gold"). ■

▲ *Mining was the principal source of revenue for Spain and Portugal from their colonies. The mining industry, however, brought prosperity to very few people in Latin America. It depended on labor provided by native Indians. When their numbers dropped dramatically due to diseases introduced by European settlers and ill-treatment after 1650, the production of silver, in particular, also fell. This woodcut of 1535 shows Indians panning for gold.*

By 1750 France was influencing artistic style throughout Europe. This influence also spread to European colonies throughout the world. The Rococo style emerged in France about 1700 and its impact was felt internationally throughout the century. This artistic and decorative style is concerned with fragile decorative detail, complexity in design, a light touch in color and choice of subject matter.

In Brazil, beginning about 1750, many architectural projects were commissioned. Their number and variety reflected the financial prosperity brought to the country by mining projects. Churches in the town of Ouro Preto carried the Rococo style the furthest in Latin America. Their façades were plain, smoothly stuccoed and curving. These churches were

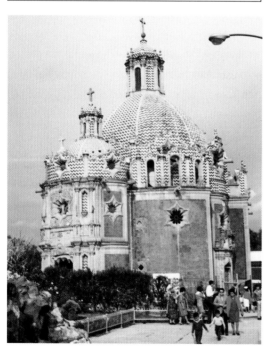

▲ *Rococo spirit can be seen in the curved façade of this small, oval church built between 1777 and 1791 behind the Basilica of Guadalupe, north of Mexico City. Francisco Guerrero y Torres (1727-92) designed it.*

Spanish Viceroyalties

The original Spanish colonies, or viceroyalties, were New Spain and Peru. In 1717 another viceroyalty, New Granada, with its capital in Santa Fe de Bogota, Colombia, was split off from Peru. It included the modern countries of Ecuador, Colombia, Panama, and Venezuela. Quito in Ecuador served as the sculptural center of this viceroyalty in northwestern South America. In 1776, a fourth Spanish viceroyalty was created, comprising what are now the countries of Argentina, Uruguay, Paraguay and Bolivia. It was called La Plata, for the River Plata, which flows through this region to the Atlantic Ocean. ■

▲ *The school of Quito was most successful at producing the doll-like, Rococo sculpture with soft, pink-toned flesh such as this infant Christ Child made in 1792. The figure embodies the essence of Rococo style. There is no hint that it was produced by an Indian artist, Manuel Chil, also called Caspicara, which means pock-marked face.*

This painting of Joseph and the Infant Jesus is by an unknown artist probably of Indian back-ground. It is typical of the school of Cuzco during the 1700s, which worked in the Rococo style. The Cuzco school became successful after an earthquake destroyed Cuzco in 1650. Male artists of mainly Incan descent, such as the painter Diego Quispe Ttito and the wood sculptor Juan Tomás Tuyrutupec, were founders of this school. ▼

Tupac Amarú Rebellion _____

Inca royalty survived throughout the colonial period. Both real and imagined portraits were made of figures of Inca nobility during the 1700s. A well-educated leader, José Gabriel Condorcanqui, took the Inca name of his ancestor Tupac Amarú II, who had been beheaded during a rebellion in 1572. He sparked a rebellion in 1780 by hanging a hated Spanish official and encouraged the writing of a constitution for Peru. Sixty thousand Indian peasants supported him until he was captured in 1781, condemned, and torn apart by horses. ■

small in scale and had delicate details, such as small, oval windows.

In Peru, a Cuzco school of painting was established in the 1600s, made up of Indian and *mestizo* artists. Some experts believe that the flat, ornamental painting these artists produced is a continuation of Pre-Columbian design in textiles and pottery. In Cuzco during the 1700s, artifacts of the Inca culture could still be seen, such as painted wooden cups, folk weaving and portraits of Indian leaders. By the mid-1700s, Cuzco painting began to have Rococo features, such as the use of soft reds, blues, and ochers; small-scale, doll-like facial features and tender, intimate expressions. The Virgin Mary was often portrayed dressed as a Spanish peasant, an informal touch typical of the Rococo style. The tropical landscape in which scenes were often set was imaginary, based on prints showing European ideas of Egypt, rather than direct observation of the Amazonian rain forest.

Colonial artists were interested in painting daily life in the Spanish colonies before 1824 when independence was achieved in mainland nations. Antonio Pérez de Aguilar painted the fruits of Mexico in kitchen still lifes. In Quito, Vicente Albán combined still lifes in land-scapes with idealized portraits of people in their typical costumes.

In the 1790s, an anonymous Bolivian artist painted pairs of people of different native groups in their distinctive costumes. The different levels of colonial society are best seen in several series of paintings produced by Mexican artists. Each represents intermarriage of different races and assigns a name to each mixture of race. The further removed from pure blood the couples are, the more humbly their surroundings are depicted. The influence of the French Rococo expression can be felt in the intimacy of the scenes of people and homely subjects, which made painting of ordinary life acceptable in Latin America in the late eighteenth century.

In the late 1700s, Latin America had become a place where people from many parts of the world met and mixed. This mixture of peoples and cultures was a creative force, giving rise to new ideas and art. Children of the same family could look very different. Skin color did not automatically determine what individuals could do.

Neo-Classical Art, 1783–after 1830 A.D.

◀ *Manuel Tolsá's largest surviving sculpture is the bronze statue of King Charles IV of Spain on horseback, of 1803. This large scale in casting was never before attempted in the colonies.*

Spain made its first attempt in 1783 to exert control on its colonial American arts by founding the Royal Academy of San Carlos in Mexico City. To head each artistic section Spaniards were sent to Mexico. The most impressive director was Manuel Tolsá (1757–1816), who taught sculpture and later served as director of the Academy. He worked in the Neo-Classical style, based on Greek and Roman ideas and using calmer, simpler forms than Rococo artists had.

In the mining town of Guanajuato, a native-born and self-taught architect and talented painter, Francisco Eduardo Tresguerras (1759–1833) designed Neo-Classical buildings. His self-portrait is unflatteringly realistic, painted against a plain, gray background. The painting recalls the work of the Spaniard, Francisco Goya (1746–1828), court painter to Charles IV (1784–1819) of Spain.

In 1807, King John VI (1769–1826) of Portugal moved to Brazil to avoid Napoleon Bonaparte's (1769–1821) armies. Peace came to Portugal in 1814 but he stayed on. In 1816 he brought a group of French Academy artists to Brazil who become the teaching faculty of the new Imperial Academy of Fine Arts in Rio de Janeiro. Auguste Taunay (1768–1824) taught sculpture and his brother, Nicolas (1755–1830), painting. Nicolas's paintings of Rio de Janeiro emphasize the great feeling of space in the new world. In 1822, after King John returned to Portugal, his son Pedro (1798–1834) declared independence and became the first emperor of Brazil.

The Neo-Classical style continued in Latin America long after it had faded in Europe. Self-taught artists honored their heroes and the great events of Latin American independence using a straightforward and realistic Neo-Classical style. Much architecture also kept its classical features.

Popular Heroes

Among the heroes of the wars of independence, Simón Bolívar (1783–1830) must be considered the most popular. Bolívar was born in what is now Venezuela, and fought to liberate the viceroyalty of New Granada. In Peru he joined the liberators of southern South America, José de San Martín (1778–1850) and Antonio José de Sucre (1793–1830), to defeat the Spanish forces finally in 1824. The new republic of Bolivia was named in his honor. Bolívar was the liberator most often represented in works of art from this period. ■

◀ *Eduardo Tresguerras's frescoes in the church of El Carmen in his birthplace, Celaya, Mexico, were painted probably after 1807 in the Neo-Classical style using pale colors.*

Independence

By 1824, mainland Latin American nations had won their independence from the two mother countries, Spain and Portugal, which had been weakened by the Napoleonic wars. By 1839 the four former Spanish colonial viceroyalties had become fifteen independent republics. Brazil remained a united empire. Economically and culturally these new states looked toward Europe and, in the twentieth century, they looked increasingly toward the United States. ■

Romanticism

Romanticism was a revolt in all the arts against the calm and measured order of Neo-Classicism. The French Revolution began in 1789, overthrowing the rigid order of the past. In the same way, Romantic artists had begun to feel they had had enough of strict rules dictating how they should work. Over the next thirty years the Romantic style began to appear throughout Europe. It reached England and Germany first and then France. Romantic artists were interested in individual expression, using their intuition and instinct, emotional content and representing the picturesque. ■

Following the wars of independence in Latin America, many European travelers came to see the Americas in their romantic search for the unusual, the dramatic, and the picturesque. Artists such as Johann Moritz Rugendas (1802–58) from Germany, Jean-Baptiste Louis Gros (1793–1870) from France and Daniel Thomas Egerton (approx. 1800–42) from England captured the reality, the beauty and excitement of the now independent Latin American countries.

France was still the cultural center of the western world, and would remain so for some years. Educated, native-born Latin American artists in the nineteenth century went abroad to study. Some returned to South America to paint scenes of Brazil, Argentina, and Chile. They focused on local customs, landscape, popular character types, capturing the specific and unusual aspects of a place. They looked at their countries as Europeans would, rather than through Latin American eyes. This point of view was represented in their paintings.

Self-taught artists, in provincial areas, far away from the capital cities, produced still lifes and religious works but also painted portraits of local characters, leaving an important record about provincial society. José María Estrada (approx. 1810–65) from Guadalajara, Mexico, painted true-to-life portraits of local people. It was important to the client that a realistic interpretation of the sitter's character, clothing, age and station in society be captured by artists like Estrada.

José María Estrada's Portrait of Don Francisco Torres (The Dead Poet), *1846, in oil was painted in memory of the dead poet. The inscription records biographical details.* ▼

View of the Environs of Lima *by the Bavarian artist Johann Moritz Rugendas, was painted in 1843 in oil on canvas. Rugendas is unusual because he documented a number of countries. He began his Latin American journey in Brazil between 1820 and 1823.* ▼

29 Academic Realism, approx. 1850–1900 A.D.

▲ *Manuel Vilar (1812–60) honored a brave Indian warrior killed through ritual sacrifice using the Hellenistic style of ancient Greece. This is the 1851 plaster version of* The Tlaxcalan General Tlahuicole Doing Battle on the Gladiator's Stone of Sacrifice.

▲ *Miguel Noreña's (1843–94) heroic, bronze statue of the last Aztec emperor, Cuauhtemoc shows the move in academic sculpture towards native subjects by 1877, when this monument was built.*

In the new Latin American republics local artists were often overlooked and commissions for new works of art were generally given to Europeans. In Mexico City, the Academy closed its doors after independence, but in 1847 General Antonio López de Santa Anna (1797–1876), president and dictator of Mexico for many years between 1822 and 1855, brought teachers from Spain and Italy to Mexico to reopen it. Academic painting had begun to lose its appeal in Europe, as a new interest in avant-garde works took hold. Wealthy

48

▲ The Discovery of Pulque *by the Mexican artist José Obregón was painted in 1869. The design of the throne may have been copied from a Pre-Columbian Mixtec book. The architecture in the background was completely invented by the artist. While some of the costumes of Obregón's characters may be authentic, the figures themselves look like they stepped out of works of art from ancient Rome.*

Imperial Brazil

In Brazil independence was finally achieved by Dom Pedro, son of John VI of Portugal. He was supported by Brazilian conservatives. They liked the monarchy but resented the stronger control of Brazil imposed by the Portuguese government. In 1822 Dom Pedro was crowned Pedro I, Emperor of an independent Brazil. This branch of the Portuguese royal family ruled until 1889. The new constitution of 1824 was so sound that it served Brazil for over sixty years. Brazil was the last country in the Americas to abolish slavery in 1888. Emperor Pedro II (1825–91) who had reigned since 1831 was deposed by the army. This was in part due to the monarchy losing the support of the São Pãolo coffee planters who resented the abolition of slavery. Brazil became the republic it is today in 1889. ■

Mexicans and the conservative government, however, still found the old-fashioned academic style to their liking. Since religion was considered the backbone of stable, conservative life in Latin America, academy students continued to turn out religious works. However, the paintings of the students of the 1850s were based on biblical scenes of war, natural disaster and family strife. These were years of great civil conflict and these paintings were a reflection of the times.

History painting was a standard class taught at the Academy. Students were encouraged to paint subjects from the Mexican past. José Obregón (1832–1902) and others tried to recreate ancient historical events in their works. They asked Indian models to pose wearing native costumes recreated from Indian books made before and after the European conquest. These are the only historically correct elements.

The Italian Eugenio Landesio (1810–79) arrived to teach landscape painting at the Mexican Academy in 1855. He emphasized classic composition, drawing on the wild beauty of Latin America's scenery as a backdrop for real-life scenes. Landesio's paintings were popular and he founded a school of landscape painting. The Mexican José Mariá Velasco (1840–1912), Landesio's student, was probably the best academic painter in Mexico. He painted landscapes, particularly the Valley of Mexico, in a passionate, classical, romantic style.

Brazil continued to support the academy of art founded by the Portuguese royal house in 1816. Its artists painted imaginary scenes of Amazon people and scenes with billowing flags meant to represent order and progress, the motto of the Brazilian republic.

José Mariá Velasco based many landscape paintings on views of the Mexican countryside around Mexico City. His View of the Valley of Mexico from the Hill of Santa Isabel *was painted in oil on canvas in 1877.* ▼

30 *Modernismo*, approx. 1890–1920 A.D.

From the early 1890s Academic Realism began to be replaced by *Modernismo*, a movement that spread to other branches of Spanish American culture including music and literature. In Mexico, the Academy of San Carlos (renamed the Escuela de Bellas Artes in 1867) awarded scholarships to local artists to study in Europe in the new 'centers of modern art such as Paris, Munich, Karlsruhe and Barcelona. In Mexico many of these artists, sometimes known as *Modernistas,* adopted the current European styles of Cubism, Impressionism, Symbolism, Naturalism and Art Nouveau which they often combined in their paintings with strong local themes and influences.

Broadsheet Art _____

The broadsheet—a printed text accompanied by an engraved illustration—was a feature of Mexican life particularly during the dictatorship of Porfirio Diaz (1830–1915). The period of his dictatorship (1876–1911) is called the *Porfiriato*. Broadsheets were printed in great numbers, sold at low prices and distributed by printers, street vendors and in the markets. They covered many topics, including the Mexican annual festival of the Day of the Dead, sensational news like murders and riots, and social and political events which they could caricature. The broadsheet was the most vigorous form of social criticism in Latin America in this period. The leading illustrator of the broadsheets was the engraver, José Guadalupe Posada (1852–1913). He drew boldly expressive images on scratchboard and directly on metal printing plates to ridicule all aspects of life during the *Porfiriato*. ■

▲ *Saturnino Herrán painted* Woman from Tehuantepec *in oil in 1914 as a tribute to his wife, Rosario. In his work he created a new, nationalistic modernism.*

Saturnino Herrán (1887–1918) represented Mexican Indian life using visible outlines around bright colors, both features of French Post-Impressionism. His long lines and snaky curves are typical of the European Art Nouveau movement.

Modernismo's reaction against Academic Realism became increasingly political in Mexico by the eve of the revolution of 1910. The painter, Dr. Atl (1875–1964) organized an exhibition in Mexico City of Mexican artists, to compete with the government's official show of European artists. His own work of volcanic Mexican landscapes, produced with homemade waxy crayons, used the emotional colors and sweeping lines of Post-Impressionism.

The work of Diego Rivera (1886–1957) used cubist techniques which flattened and twisted forms that could be seen from different angles at the same time. Rivera went to Paris on a Mexican government scholarship.

▲ *Dr. Atl used oil on masonite to produce* The Volcanos *in 1950. He emphasized the raw power of the Mexican landscape in this painting.*

Revolution

Between 1910 and 1920 Mexico was convulsed by a revolution in which peasants, *mestizos* and Indians fought to regain land and village autonomy. Two leaders of the revolution were Emiliano Zapata (1879–1919), who fought with his followers called the *Zapatistas* in central and southern Mexico, and Pancho Villa (1873–1923) and his hard-riding armies in the north. Both were eventually defeated. The victors implemented many of the revolutionaries' demands seen as the key to a stable and peaceful Mexico. The new constitution of 1917 included provisions for labor protection laws, land reform and education. In 1920 President Obregon made further land reforms but not until the presidency of Lazaro Cardenas (1934–1940) were the aims of the *Zapatistas* were fully accepted. ■

▲ *Diego Rivera painted* Zapatista Landscape—The Guerrilla *in oil on canvas in 1915. In this Cubist-inspired work, Rivera uses a straw hat, serape and rifle, the essentials of a follower of Emiliano Zapata, the Mexican revolutionary hero. This was a favorite subject of this artist. Rivera's* modernismo *style was strongly influenced by his knowledge of the Mexican Revolution.*

31 Mexican Mural Paintings, 1921–approx. 1950 A.D.

In his project for the Ministry of Public ▶ *Education headquarters in Mexico City from 1923 to 1928, Rivera painted directly on wet plaster. His subjects illustrate Indian and mestizo culture while keeping the geometrically simplified, powerful outlines which he admired in Giotto and the early Renaissance painters in Italy. This is* Urban Day of the Dead (The Fair on All Souls' Day), *just one of the 116 major fresco works he painted for the ministry that were funded by the government. When he finished this enormous project in 1928 he not only had established his distinctive style but also his reputation as Mexico's leading muralist.*

Latin American Communism

Marxist Communism has been a vital force in Latin American thinking for most of this century. It is especially strong among idealistic youth in the universities, who embrace its thinking but soon abandon it. Its policies of free social and medical services and no private property also attract the landless poor. Fidel Castro formed a Marxist government in Cuba based on similar ideas in 1960. Other radical governments were set up by Salvador Allende in Chile from 1970 to 1973, and by Daniel Ortega in Nicaragua from 1979 to 1990. While these men used some communist ideas, they did not try to eliminate private property and believed in democratic elections. Public murals and poster art have been used in all these states to communicate with the people. ■

After the Mexican revolution, by 1921, a more stable government controlled the country. The government invited many Mexican artists, through projects it sponsored, to paint murals on the walls of public buildings. The first major project was the National Preparatory School for boys in Mexico City. Diego Rivera jumped at the chance to put into practice theories which he and fellow student David Alfaro Siqueiros (1896–1974) had discussed. They believed art must relate to life and inspire people to make changes in their lives. In the theater of the school, Rivera painted a scene in the style of Renaissance religious

A Cultural Revival

The Mexican nation after the revolution was seen by some artists as a *mestizo* nation formed from the Indian and Spanish cultures. Rivera's and Orozco's murals show that Indians and others helped create the modern Mexican nation. This raised interest in the Indian past. ■

▲ *This is a sketch for the beautiful stairway fresco by José Clemente Orozco in the National Preparatory School of Mexico City. It represents a Franciscan friar comforting a starving Indian.*

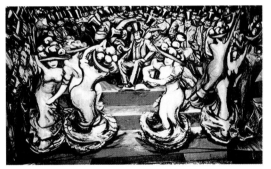

▲ *David Alfaro Siqueiros was concerned with the contemporary class struggle. He used a historical scene in this 1957 fresco entitled* General Porfirio Diaz and His Courtesans.

frescoes. Rivera gave up Cubism because it was not a style that the general public could easily understand. He decided that imaginary scenes like the one he painted in the theater, did not suit his art theories.

Another Mexican artist, José Clemente Orozco (1883–1949), also painted frescoes at the school using religious images to deal with the theme of the Mexican Revolution. Orozco used dark colors and powerful diagonals in his composition to expose the human cruelty and chaos of war. Orozco produced his finest murals when he returned to his home town of Guadalajara after seven years in the United States. Painted within the beautiful clean lines and curves of the interior of the Cabañas orphanage designed by Manuel Tolsá over a hundred years earlier, his frescoes are about the conquest of Mexico. In the murals Orozco addresses the universal themes of struggle and achievement. Spaniards and their horses are represented as machines, suggesting a connection to the contemporary world. The vibrating colors, and broad brush strokes tie Orozco's work to the twentieth century Expressionist movement.

Another Mexican mural artist, David Alfaro Siqueiros, was a Communist who spent much time writing propaganda and organizing labor unions. He painted masses of people with almost identical, simplified faces. He painted with commercial materials such as enamel paint applied using an airbrush, a technique that allowed him to cover large areas quickly. When he painted murals Siqueiros transformed the architectural space by adding panels and plastered frameworks, covering all these elements with paint. His first fully developed work was produced in the Escuela México in Chillán, Chile in 1941. The histories of Mexico and Chile are united through the use of figures of Indian leaders, conquistadors, and liberators on opposite walls linked by a sweep of color across the ceiling. Siqueiros borrowed his dramatic sense of movement from the Italian Futurist style.

Memories of a Past Culture

South American countries which had a strong Pre-Columbian history honored their still-vibrant Indian cultures in their art. Surprisingly, however, they did not use Pre-Columbian motifs. José Sabogal (1888–1956) led the movement in Peru; Oswaldo Guayasamín (1919–) does in Ecuador. Ignacio Gómez Jaramillo (1910–70) received important government mural commissions in Colombia, in which he incorporated images of Indian culture. ■

Oswaldo Guayasamín was more concerned with personal emotions, than public struggles in The White Coffin. *The painting has a geometric structure in its composition and shows the influence of Orozco.* ▶

▲ *When Emilio Pettoruti returned to Buenos Aires from France in 1924, people did not like his first exhibition of cubist paintings. This oil painting,* The Last Serenade, *1937, flattens the musicians' bodies into geometric, Cubist planes.*

The Uruguayan painter, Joaquín Torres-García incorporates colorful geometric designs of the Tiwanaku culture in this work in oil of 1943, entitled The Constructive Ship America. ▼

East of the Andes and in the southern region of South America, contemporary artists were eager to experiment with the art styles of Europe. Diego Rivera had abandoned his early experiments in Cubism, but Emilio Pettoruti (1892–1971) remained firmly committed to it from the time he returned to his native Argentina in 1924. Despite rejection, he persisted with Cubism. Argentina became a major center for the international abstract art movement in the early 1960s, until the 1966 military coup pushed many artists to leave the country.

Joaquín Torres-García (1874–1949), born in Uruguay, was a Cubist artist who worked in Europe until his return to Uruguay in 1934. Torres-García's work containing flattened, evenly-colored objects and geometric shapes separated by thick black lines, reveals an underlying unity of design. He tried to incorporate Pre-Columbian design elements from South America in his paintings.

The modern art movement was launched in Brazil by Modern Art Week, a festival of music, literature, painting and sculpture held in São Paulo in 1922. The organizers showed works that represented modern movements in European art such as Cubism and Expressionism but they also wanted to use Brazilian themes such as the mixing of races and cultures to create a national art. In the work of the Cubist Tarsila do Amaral (1890–1973), who studied in Paris until 1924, the avant-garde styles of Europe and Brazil are combined. In her paintings she distorts the human figure in certain works. She also painted rural and urban landscapes. Tarsila do Amaral, in a career covering forty years, is considered the leading exponent of Brazilian modern art.

City planning, ignored in Latin America since the time of the Laws of the Indies in the late sixteenth century, was revived. A new capital city for Brazil, called Brasília, was constructed in the sparsely settled central plateau of the country, realizing an old dream of many people

Expressionism _____

Expressionist painters are not interested in recording what they see in a naturalistic way. They distort and exaggerate shapes or colors to express their emotions and reactions to what they are painting. Expressionism was a dominant force in German art from 1905 to 1930, and throughout northern Europe and France. It influenced the work of many artists and important art movements throughout the world in the twentieth century. ■

When she returned to her native Brazil from ▶ *Europe in 1924, Tarsila do Amaral began to paint abstract, geometric views of tropical landscapes like* Central Railway of Brazil *of 1924, painted in oil on canvas.*

from the time of independence. The main buildings of Brasília, were designed by Oscar Niemeyer (1907–). Their dramatic curves are made of reinforced concrete.

The buildings of the National Autonomous University of Mexico, constructed between 1949 and 1954, use curves, sharp angles, bright colors, contrasting textures and mosaics. The focal point is the library building, covered with mosaic murals designed by architect Juan O'Gorman (1905–1982). O'Gorman had designed rigid, functional architecture in the 1930s making no concessions to Mexican taste or the need for shade. O'Gorman's work marks Latin America's conversion from a rigid international style to one more suited to each country. Many Latin American artists today still attempt to translate international movements into their own vocabulary.

▲ *Lúcio Costa (1902–) won the design competition with his plan for Brasília in 1956. His project was sketchy, but it had a bold sweep. An axis made up of huge government buildings crosses the swept-back wings representing the residential areas. The design plan was intended to look like a jet plane.*

Brasilia

In 1956, the newly elected President of Brazil, Juscelino Kibitscheck decided to build a new capital 600 miles/960 kilometers inland from the existing one, Rio de Janeiro, in a virtually uninhabited part of the country. Inaugurated as the new capital in 1960, Brasília, as it was called, was intended to be a symbol of Brazil's progress and growing economic power. The city is laid out in the shape of a bent bow and arrow. Brasília's ultra modern architecture has become famous all over the world for the boldness of its design. ■

◀ *Juan O'Gorman's rectangular library building can be seen in the background in this photograph of some of the National Autonomous University of Mexico buildings, built between 1949 and 1954.*

33 Surrealism, 1938–1970s A.D.

Surrealism and Primitive Art

Between 1900 and 1950, all art made outside western and oriental civilizations, including Pre-Columbian art, was categorized as primitive art. The Surrealists believed primitive art drew on the creative subconscious mind. They used their art to explore the subconscious and they saw Pre-Columbian, African and other primitive forms of art as rich sources for their art. ■

▲ *Frida Kahlo's double self-portrait of 1939,* The Two Fridas, *shows two aspects of her character. The proper, westernized lady is on the left and the Tehuana Indian woman on the right. They are connected by blood. Her work often includes references to Mexican folk art and the Pre-Columbian village sculpture of west Mexico. A mix of ancient and modern Mexican themes is also seen in many of Kahlo's paintings.*

Surrealism is a modern European style which has received the most enthusiastic response in Latin America. Surrealism is an art movement, started in France, that tried to explore the creative possibilities of the subconscious mind. It places emphasis on the irrational, the emotional, and the personal. In 1938 and 1940, the French poet-philosopher André Breton (1896–1966), visited Mexico and helped to firmly plant Surrealism in the Americas. He considered his hostess, Frida Kahlo (1907–1954), the wife of the painter Diego Rivera, to be a natural Surrealist. Long before his visit, she was painting intense self-portraits that incorporated her dreams. Surrealist artists were interested in Latin American primitive art and folk art since these forms of art tapped into the instinctive spirit and essential concerns of all people.

José Luis Cuevas (1934–) is another Latin American who works with Surrealist ideas. He takes characters from works by Diego Velázquez, Francisco Goya, and Pablo Picasso, the great figures of Spanish art and often combines them with self-portraits.

The Zapotec Indian painter, Rufino Tamayo (1899–1991), who produced murals, among other works, made his most important artistic statements after 1940. He combined in his paintings references to Mexican identity with Surrealistic abstraction and Expressionistic colors. Tamayo preferred to work in the smaller size of easel painting instead of the large size required for murals. He felt it was a more intimate scale to express his personal Surrealist vision.

Other Latin Americans who came in contact with Breton and his surrealist circle have made important contributions. Raised in Chile before moving to Paris, Roberto Matta Echaurren (1911–) made paintings using abstract, organic shapes. He remains one of the best known Latin American Surrealists. Wifredo Lam (1902–1982), who was raised in Cuba, fled the Nazis in Europe with Breton and his circle, and returned to his native Cuba during World War II. Lam had

Folk Arts

Folk Art takes many forms in Latin America. Brightly painted houses and creative signs are found in poor neighborhoods. Paintings are produced by untrained artists as offerings in religious cult ceremonies. Day of the Dead celebrations (All Souls' Day, November 2) inspire figures made by artists to symbolize the dead. Colorful ceramics, textiles and jewelry are made in every region. ■

▲ Wifredo Lam's dramatic, Surrealist paintings often recall religions of primitive societies. In The Jungle of 1943, *the large, standing figures with angular faces look like African sculpture in this tropical fantasy.*

▲ The painter, Fernando de Szyszlo, born in Peru in 1925, captures the turbulent effects of a powerful earthquake in his Andean homeland. The heavy, painted shapes capture the essence of Inca architectural stone forms in this acrylic on canvas work of 1970, entitled Runa Macii, which means "fellow man" in the Inca language.

an Afro-Cuban mother who was a priestess in a cult that practiced a religion based on African beliefs. Lam's first Paris contact was Pablo Picasso, who at the beginning of the twentieth century, used African sculpture as an important source in his Cubist work.

The Abstract Expressionism which rose up in New York in the late 1940s, was partly inspired by the Surrealists. It has many followers in Latin America and is called Informalism in Latin America. The more geometric and carefully constructed works such as the work of Joaquín Torres-García are called Formalism. Many Informalist artists refer to the natural forces in their homelands in their work. Latin American art is often concerned with inner reality. In colonial times, religious vision was the focus. In the period after independence the soul of the nation provides inspiration for artists.

The Surrealists ▶ admired the work of the voodoo priest and painter Hector Hyppolite. Breton believed paintings, such as this one in oil, Agoué and his Consort, 1945–48, showed Hyppolite "had an important message to communicate, that he was the guardian of a secret."

Magic and Primitive Religion____

The Surrealists became interested in magic and "primitive" religions. In 1945, André Breton was impressed by the paintings of the Haitian, Hector Hyppolite, an initiated voodoo priest. Voodoo is a religion derived from the religions of Yoruba and Dahomey slaves who came from Africa. The Cuban, Wifredo Lam, also painted voodoo scenes, but his were more general statements than Hyppolite's, probably because he was not an initiate. ■

34 Recent Art

Urban Explosion _____

As in all underdeveloped countries, the major cities of Latin America swelled tremendously in the last quarter of the twentieth century. Rural migrants looking for work and a better standard of living have poured into the cities. They often build temporary shelters on unoccupied land which then become permanent shanty-towns called *favelas* in Brazil which totally lack public services. Unemployment, illiteracy, disease and hunger contribute to the misery of these slums. However, within the shantytowns life continues without the help of government support. ■

▲ *Few families that live in the* favelas *of Rio de Janeiro have plumbing or drinking water which must be carried home in any containers that may be handy.*

Some artists who painted in the Informalist abstract style returned to realistic representation. Armando Morales of Nicaragua (1927–), who painted geometric abstractions in the early 1960s, now creates serene tropical forest scenes in a Surrealistic style. Such images have been linked to the Magical Realism of modern Latin American literature. The Uruguayan artist, José Gamarra (1934–) also paints thick, tropical forests with figures from the Spanish conquest. In Gamarra's painting entitled *Links* of 1932, the revolutionary Nicaraguan Augusto Sandino (1895–1934) appears like a vision to a bow-wielding Indian. In both Gamarra's and Morales's paintings the tropical forest

▲ *A political revolution in Nicaragua brought the radical Sandinistas to power in 1979. Armando Morales commemorated the founders of the revolution of the 1930s in* Farewell to Sandino. *In the painting of 1985, Morales arranges the characters like saints in a Renaissance altarpiece.*

Magical Realism _____

Magical Realism is a new technique in which Latin American novelists use symbols, fantasy and flashbacks to point out the absurd in life and to protest injustice. The Argentinian writer Jorge Luis Borges (1899–1986) used fantasy to show the pointlessness of life in his novel *Ficiones* (1945, Fictions). In *Conversations in the Cathedral* (1970) Mario Vargas Llosa (1936–) employs verbal and structural disorder to show the disorder in Peruvian life and geography. Fantasy is the method adopted by Gabriel Garcia Márquez (1928–) to attack the character of Colombian society and politics in his novel *One Hundred Years of Solitude* (1967). ■

overwhelms the figures and seems to press in upon the viewer.

The need to sell their work, to find support from fellow artists and to escape from political regimes that do not support their ideas have led many artists to leave Latin America. When democracy returned to Argentina in 1983 and Brazil in 1985, the creative spirit began to flourish again and the ability to sell art improved. Buenos Aires now has more than sixty galleries dedicated to contemporary art. Others have begun to sprout up throughout Latin America.

High inflation rates in Latin America inspired the Brazilian assemblage artist, Jac Leirner (1961–), to make works of art stringing the country's worthless, paper money into long strands that fall in beautiful curves. Latin Americans have to be adaptable to live with dramatic financial and political changes; so too must their artists.

Many artists continue traditions in folk arts which have survived since the European conquest. Trained artists consciously refer to folk art or even use actual folk art works, like Oswaldo Viteri (1931–) of Ecuador. He gathers brightly-colored, fabric dolls made by Indian villagers, and glues them to the large wooden boards he paints. During

▲ *In the 1970s the Argentinian painter Antonio Berni (1905–81) created collages full of humor and compassion about the lives of two imaginary characters, Juanito Laguna, a street urchin, and Ramona Montiel, a prostitute. In this collage,* Juanito Laguna *of 1978, Berni recycled materials he found in the trash to create this urban scene from Juanito's life.*

In The Eye of Light, *Oswaldo Viteri works with small, fabric dolls made by highland Indians to provide the symbolism in this collage on wood of 1987.* ▼

▲ *Many old folk art traditions are still kept alive in Latin America today. This tree bark painting was made with natural pigments by the Tururi Indians of the Amazon basin.*

the military dictatorship of General Pinochet (1915–) in Chile, female family members of people who disappeared or were jailed remembered their loved ones' lives in images made using fabric scraps stitched on burlap, echoing traditional Indian women's crafts.

Latin American artists are searching for their own identity, in the shared past of its people, in popular culture and in their own lives and personal experiences. Latin American art has often adapted styles from Europe and the United States and added images taken from the tradition of its own people. Recent art reflects popular culture both in its images and in the materials it uses.

Bibliography

Ades, Dawn. *Art in Latin America: The Modern Era, 1820–1980*. New Haven: Yale University Press, 1989.

Bayón, Damién, and Murillo, Marx. *History of South American Colonial Art and Architecture*. New York: Rizzoli, 1989.

Benson, Elizabeth P. *The Mochica: A Culture of Peru*. New York: Praeger, 1972.

Bruhns, Karen Olsen. *Ancient South America*. New York and Cambridge, England: Cambridge University Press, 1994.

Castedo, Leopoldo. *A History of Latin American Art and Architecture*. New York: Praeger Books, 1969.

Catlin, Stanton Loomis, and Terence Grieder. *Art of Latin America Since Independence*. New Haven: Yale University Art Gallery and the University of Texas Art Museum, 1966.

Chase, Gilbert. *Contemporary Art in Latin America*. New York: The Free Press, 1970.

Grizzard, Mary. *Spanish Colonial Art and Architecture of Mexico and the U.S. Southwest*. Lanham, Maryland: University Press of America, 1986.

Kubler, George. *Art and Architecture of Ancient America*. Baltimore: Penguin Books, 1984.

Lucie–Smith, Edward. *Latin American Art of the 20th Century*. New York and London : Thames & Hudson, 1993.

Lumbreras, Luis G. *The Peoples and Cultures of Ancient Peru*. Washington: Smithsonian Institution Press, 1974.

Miller, Mary Ellen. *The Art of Mesoamerica from Olmec to Aztec*. New York and London: Thames and Hudson, 1986.

Moseley, Michael Edward. *The Inca and Their Ancestors: The Archeology of Peru*. New York and London: Thames and Hudson, 1992.

Rasmussen, Waldo, ed. *Latin American Artists of the Twentieth Century*. New York: The Museum of Modern Art, 1993.

Schele, Linda, and Freidel, David. *A Forest of Kings: The Untold Story of the Ancient Maya*. New York: William Morrow and Co., 1990.

Thompson, Robert Farris. *Flash of the Spirit: African and Afro-American Art and Philosophy*. New York: Random House, 1983.

Weismann, Elizabeth Wilder. *Art and Time in Mexico from the Conquest to the Revolution*. New York: Harper and Row, 1985.

Acknowledgements

The author wishes to thank Leasha Tavernier and Jennifer Courts for their assistance with the manuscript.

Glossary

Abstract Expressionism The modern art movement that developed in New York during the 1940s which is called Informalism in Latin America and France. A spontaneous freedom of expression characterized the work of these artists.

Art Nouveau A decorative style of art and architecture which spread from England to western Europe and the Americas in 1890 and continued to be popular until World War I.

avante-garde Art or ideas that are experimental and pioneering.

Baroque The artistic style in Europe that dominated in the seventeenth century, concerned with balance achieved through the harmony of all the parts of a work of art.

buttress A structural support usually made of brick or stone which adds strength to a wall.

cloister An enclosed walkway surrounding an interior courtyard or patio in a religious building or college.

conquistador The Spanish word for conqueror used to describe the Spanish leaders who conquered parts of the Americas in the sixteenth century.

Cubism An important art movement in which the object or scene was represented as if the viewer could see it from many perspectives in a single painting, collage or sculpture.

Expressionism Art in which shape or color are exaggerated and the idea of painting things to look like they do in nature is abandoned by the artist.

fresco A type of painting made on wet plaster.

Futurism A political art movement that hoped to free Italy from the old-fashioned ways of its past. Its influence spread to Russia and other parts of the world.

Impressionism A painting movement that began in France in the 1860s and which was opposed to academic painting. To capture the immediate visual impression of a subject was the main concern of Impressionist artists.

Mesoamerica The land area of Middle or Central America that included modern Mexico and the Maya area in Guatemala, Belize, El Salvador and western Honduras.

mural A painting or collage produced directly on a wall or actually affixed to the wall.

Post-Impressionism Various styles of painting that developed after and in reaction to Impressionism, particularly in France.

Pre-Columbian The time before the arrival of Christopher Columbus in the Americas in 1492 and the European conquest of the Americas. Since European control came about gradually in the Americas the term can refer to dates from 1492 to the 1600s.

pyramid A structure with a square base and triangular sides that meet at a point on the top. Most Pre-Columbian pyramids are cut off at the top and have a cube-shaped extension built on top.

Symbolism An art movement involved with the mystical and the occult that was popular in the 1880s and 1890s in France. It came about as a reaction to Impressionism and realism. Symbolist artists felt that color and line could express ideas.

voodoo Rites and practices based on a belief in sorcery and charms or objects thought to have special powers.

Photo Credits

The producers of this book have made every effort to contact all holders of copyrighted works. All copyright holders whom we have been unable to reach are invited to write to Cynthia Parzych Publishing, Inc. so that full acknowledgement may be given in subsequent editions.

Art Museum of the Americas Archive, Washington D.C.: 53 bottom, 54 top

Benson Latin American Collection, University of Texas: 35 top left

Trustees of the British Museum: 27 top

British Library: 41 right

Chan Chan, Moche Valley Project: 31 bottom right

Church of La Compañia: 40 bottom

Cleveland Museum of Art: 16 top

Coe, W. R.: 22 top right

Costa, Lucio: 55 bottom left

Museum für Völkerkunde, Vienna: 29 bottom left

Cuzco Museum of Art, Santa Ana: 42 bottom

Dumbarton Oaks Pre-Columbian Collections, 19 right

Escuela Nacional Prepartoria, Mexico: 53 top

Florida State Museum, Gainesville, Florida: 23 bottom right

Franciscan Convent, Huejotzingo, Puebla, Mexico: 40 top

Fundacion Garcia Arevalo: 10 bottom

Archer M. Huntingdon Art Gallery, University of Austin, Texas: 59 top

Instituto Cultural Cabañas Patrimonio de Jalisco, Guadalajara, 51 top

Instituto Nacional de Antropologia e Historia, Mexico: cover, 23 top, 28, 29 top and bottom right

Lowe Art Museum, Coral Gables, Florida: 17 bottom right

Ministry of Public Education, Mexico: 52

Museo de America, Madrid: 33 top

Museo de Arte Contemporane da Universidad de São Paulo: 55 top

Museo de Arte Moderno, Mexico City: 49 right, 51 bottom, 56

Museo Nacional, Guatemala: 23 bottom left

Museo Nacional de Antropologia, Mexico: 8 left, 12 top, 28, 29 top and bottom right

Museo Nacional de Archeologia, Antropologia e Historiá, Lima: 18 bottom right, 31 top left

Museo Nacional de Arte, Mexico: 47 left, 49 left

Museo Nacional de Historiá, Mexico City: 53 center

Museo Regional de Atacama, Chile: 33 bottom

Museum of Fine Arts, Boston: 16 bottom, 32 left

National Geographic Magazine: 8 right

Neumann Foundation, Caracas: 57 bottom

Peabody Museum, Harvard University, Cambridge: 26 bottom left

Pinacoteca Virreinal de San Diego, Mexico City: 42 top

Private Collection: 9, 10 top and bottom, 11 top left and bottom left, 13 top, 14, 15 bottom, 17 top left, 18 bottom left, 21 center left, bottom left and bottom right, 24 left, 31 bottom left, 35 top right, bottom right and bottom left, 36, 37 top and bottom, 44 top right, 45 bottom, 47 right, 50, 54 bottom, 57 top and right, 58 bottom, 59 center

San Marcos University Collection, Lima: 15 top

Photos copyright © John F. Scott: 11 bottom right, 12 bottom, 13 bottom, 18 top left, 19 left, 20 top, center and bottom, 21 top left, bottom left and bottom right, 22 left, 24 right, 25 right, top left and bottom left, 26 right and top left, 27 bottom, 32 right, 34, 38 top and bottom, 39, 41 left, 43 top and bottom, 44 left, 45 top, 46 top and bottom, 48 right and left, 46 bottom, 55 bottom right

Copyright © Henri Stierlin: 30

University Museum of Archaeology and Ethnology, Cambridge: 17 bottom left

Viteri, Oswaldo: 59 bottom

Index

INDEX